MOVEMENTS IN MODERN ART

D0505151

MOVEMENTS IN MODERN ART

ABSTRACT EXPRESSIONISM

DEBRA BRICKER BALKEN

TATE PUBLISHING

Published by order
of the Tate Trustees
by Tate Publishing
a division of
Tate Enterprises Ltd,
Millbank, London
SW1P 4RG
www.tate.org.uk/publishing

*British Library Cataloguing in
Publication Data*
A catalogue record for this
book is available from the
British Library

ISBN 1 85437 306 4

Distributed in North America
by Harry N. Abrams Inc.,
New York

Library of Congress
Control Number:
2004111326

Cover design by
Slatter-Anderson, London
Concept design by
Isambard Thomas
Book design by
Caroline Johnston
Printed in Hong Kong by
South Sea International
Press Ltd

Front cover:
detail from Jackson Pollock
Summertime: Number 9A 1948
Oil, enamel and house paint on
canvas, 84.8 × 555 (33⅜ × 218¾)
Tate

Back cover:
Jackson Pollock *Summertime:
Number 9A* 1948

Frontispiece:
Philip Guston *For B.W.T.* 1952
(detail of fig.31)

Measurements are given in
centimetres, height before
width, followed by inches in
brackets

Contents

Abstract Expressionism is the first phenomenon in American art to draw a standing protest, and the first to be deplored seriously and frequently, abroad. But it is also the first on its scale to win the serious attention, then the respect, and finally the emulation of a considerable section of the Parisian avant garde, which admires in Abstract Expressionism precisely what causes it to be deplored elsewhere.

Clement Greenberg, *American-Type Painting*, 1955

To present America today as the heir of Paris is seriously misleading. Internationalism in art of the early twentieth century has been dead ... since the decline of Surrealism as the last of the Paris art movements and the fading of Parisian light-heartedness under the glare of the Depression, the war and the occupation. The earlier internationalism has been superceded by a global art whose essence is precisely the absence of qualities attached to any geographic centre. In the present globalism, there is no opening for a 'new Paris'.

Harold Rosenberg, *International Art and the New Globalism*, 1963

I

THE ORIGINS OF A NAME

The term 'Abstract Expressionism' is fraught with ambiguity and multiple
meanings. Coined in March 1946 by Robert Coates, the critic for the *New
Yorker*, in a review of Hans Hofmann's work shown at the Mortimer Brandt
Gallery, the tag has a complex history, replete with resistance and nationalistic
overtones. While Coates thought he was dignifying the 'splatter-and-daub
school of painting', as it was pejoratively known in the American press, with a
more polite moniker, the term only succeeded in compounding the confusion
regarding what, if anything, constituted the ingredients of a new movement in
American art. Something original, singular and unforeseen seemed to have
surfaced mid-century in New York with the paintings of Arshile Gorky,
Adolph Gottlieb, Philip Guston, Hans Hofmann, Franz Kline, Willem de
Kooning, Robert Motherwell, Barnett Newman, Jackson Pollock, Mark
Rothko and Clyfford Still, amongst others. But was there a cohesive and
unified direction that had coalesced into a school of like-minded aesthetic
thought? Moreover, was this work possessed of a radicality that distinguished
it from European precedents? Critics like Coates certainly seemed to think
that a shared set of artistic aims was emerging in New York. Revealingly,
however, most of the artists dubbed 'Abstract Expressionists' thought the
name a contrivance, a mere hook that failed adequately to convey the
multiplicity of their aesthetic interests.

However unwanted the label, the will to give a name to what appeared to be
a new artistic trend in New York preoccupied a number of writers and art
dealers from around 1943 into the early 1950s. There seemed to be a certain

urgency to devise a means of separating American from European modernist developments. With the influx of exiled artists, largely from France, into New York after the onset of World War II, the pressure to define the authenticity and ingenuity of American cultural expression was renewed. (A similar imperative had engaged critics earlier in the century, with the first wave of the avant-garde in New York during World War I.) Samuel Kootz, for example, in *New Frontiers in American Painting* 1943, was one of the first to claim that 'we happen to be, geographically, the art centre of the world today. War, devastation, brutality have forced artists to discontinue their work in other countries. Some have fled to these shores, where they may exercise excellent influence upon our efforts.' While Kootz had yet to 'discover *one* bright [American] hope', he wagered that the possibility of doing so was located in conjoining the two visual trends of 'Abstraction' and 'Expressionism' that had emanated from Cézanne onwards.

Kootz's conjunction of these two styles in an unwitting preshadowing of Coates's term, along with his idealised emphasis on New York's new cultural role, came with a passionate put-down of Surrealism, an embodiment, he believed, of the 'emptiness and decadence of France'. He was convinced that if art was to remain 'wholesome' or pure, it had to aspire to a certain formal rigour, structure and reserve. Sidney Janis took a more impartial position on the state of modernist art in his *Abstract and Surrealist Art in America* 1944, which followed on the heels of Kootz's screed, and which delineated more legibly the histories of the sometimes opposing directions taken by abstract and Surrealist painting. Although both writers — who were also gallerists, which might explain Kootz's distinctly one-sided view — conceded that the community of mid-century artists was international in its sweep, they also both made the *a priori* assumption that New York had not only superseded Paris as a capital, but was primed to determine the future of art.

While in the early 1940s the shape of that future remained momentarily elusive and vague, with no obvious front-runner or contending group of artists, the need to concretise the present, to channel, map and tie together the various strains of modernist art in New York, became a consuming ambition for many critics and curators. One of the first to seize on this perceived need for definition was Howard Putzel, an advisor to Peggy Guggenheim's gallery, Art of this Century, which thrived from 1942 to 1947 and which was the first showcase for one-person exhibitions of work by William Baziotes, Hofmann, Motherwell, Pollock, Rothko and Still, as well as numerous Europeans. In 1945 he orchestrated the exhibition *A Problem for Critics* at his own 67 Gallery, a project patently intended to garner the attention of the press, which it succeeded in doing. Positioning the painting of the New York-based artists Hofmann, Gorky, Gottlieb, Pollock and Rothko alongside work by European figures such as Hans Arp, Pablo Picasso, André Masson and Joan Miró, the installation proposed that a new school of art was in the making in New York, a blend of abstraction and Surrealism that Putzel felt drew on 'totemic, early Mediterranean and other archaic images'.

In the exhibition's catalogue, Putzel referred to the school as the 'new metamorphism', a description he knew to be inadequate, challenging the press

1
Jackson Pollock
Mural 1943–4
Oil on canvas
247 × 547
(97¼ × 239)
The University of Iowa
Museum of Art. Gift of
Peggy Guggenheim

8

to coin a more befitting replacement. Edwin Alden Jewell of the *New York Times*, loath to become the progenitor of any such word or phrase, since he was still uncertain that a *bona fide* movement had developed in America, designated the responsibility to 'some art museum official, or someone [who] will find as pertinent a first syllable [as in Cubism] which may be applied to the new "ism"'. This 'ism', he conceded, 'finds its most effective support among American painters ... I believe we see real American painting now.' Whatever Jewell's reluctance to conjure a tag, he deemed that a short, pithy name was in order – unlike Putzel's cumbersome 'metamorphism' – one that would instantaneously denote the primary traits of this apparently burgeoning movement.

Jewell was not the only writer to affirm that American artists had begun to forge an identity, to relinquish their aesthetic dependence on Europe. Clement Greenberg, the critic who would fast become one of the primary architects of Abstract Expressionism, acknowledged that Putzel had 'hold of something',

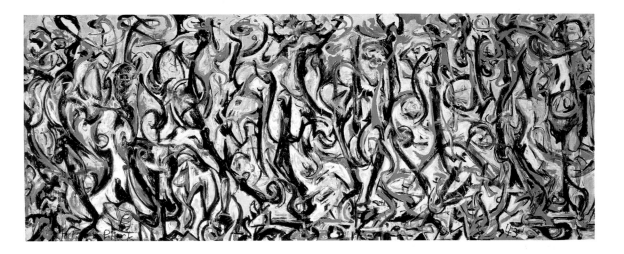

but rather than linking the work of Pollock and others with Arp and Miró, he believed the more apt analogy rested with 'Surrealist biomorphism', a thesis he set out in a review of the show in the *Nation*. As Greenberg saw it, Putzel's comparison was enfeebled by the ongoing mention of Cubism, a recently expired movement whose lingering influence was seen in the work of a handful of figures associated with the American Abstract Artists group (which had banded together a decade earlier in 1936 and took its cues variously from Picasso, Léger and Mondrian). If American painting was to assert itself, Greenberg implied, to gain hold of the international art world and market, it had to divest itself of all traces 'of Cubism and its inheritors'. And in the work of Pollock especially, which Greenberg – along with other contemporary critics such as Maude Riley – had acclaimed from the moment of his first show in 1943 at Art of this Century, a promising future augured for the Americans.

While Putzel's *A Problem for Critics* induced a certain amount of discussion,

eventually fostering Coates's lasting epithet 'Abstract Expressionism', the question as to the origins, content and form of this new work continued to engage, and rankle, many writers, as would the name. Despite Kootz's earlier insistence on an orderly and rational unfolding of the twin styles of

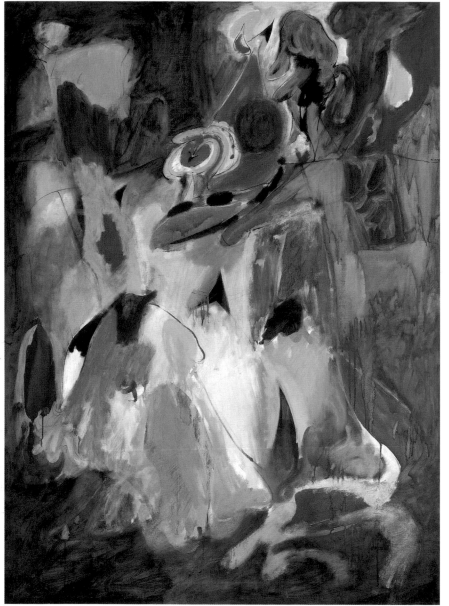

2
Arshile Gorky
Waterfall 1943
Oil on canvas
153.7 × 113
(60½ × 44½)
Tate

3
Arshile Gorky
The Liver is the Cock's Comb 1944
Oil on canvas
186.1 × 248.9
(73½ × 98)
Collection Albright-Knox
Art Gallery Buffalo,
New York. Gift of
Seymour H. Knox,
1956

'abstraction' and 'expressionism', or Putzel's notion of a Cubist-derived 'new metamorphism', the Surrealist underpinnings of this new work were too entrenched to ignore. It was Greenberg, as well as Janis and others, who had evidently got 'hold of something' in their observations regarding the pictorial

characteristics and foundations of Abstract Expressionist work. There was
clearly a link between Pollock's *Mural* 1943–4 (fig.1), Miró's decentralised 'all-
over' compositions of the late 1930s/early 1940s, and the weaving black line
that sometimes frenetically activates the work of André Masson and other
Surrealist artists. But whatever its indebtedness to European prototypes – at
least in the early stages – many of the advocates of this new art would quickly
construe it as uniquely American, a nationalistic interpretation that would
overlook contemporary foreign developments.

As James Johnson Sweeney, another critic (and curator) who responded to

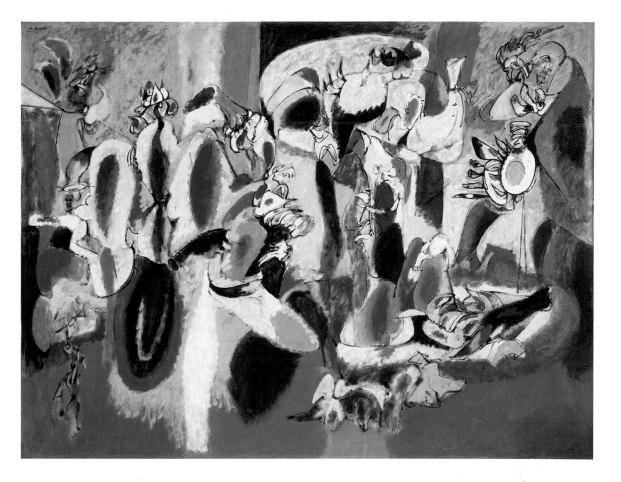

Putzel's problem, observed in the *Partisan Review* of Spring 1945, an
'expressionist direction' had begun to stand out in New York. This was
characterised by 'a greater freedom of brush work and a more excited
compositional organisation than is customarily found in the work of French
leaders'. Singling out Pollock and Gorky, Sweeney located a certain dynamism
in the painting of the New York avant-garde, a radicality that skirted the
conventions of Cubism, with all its emphasis on retaining and reworking the
so-called picture plane, and the spatial allusion or device that was its inventive
core. In works such as Gorky's *Waterfall* 1943 (fig.2) and *The Liver is the Cock's*

Comb 1944 (fig.3), the loosely applied areas of contrasting colour, unencumbered by an enveloping line or border, revealed to Sweeney and others a novel departure that had little or no visual precedent.

Gorky, an Armenian whose career unfolded in New York after 1925, was one of the first artists to forego the structural and formal preoccupations of Cubism in America. While paintings such as *The Liver is the Cock's Comb* retain a generalised debt to Picasso, an artist whom Gorky had earlier imitated, by the early 1940s these European influences had become diffused and indistinct. Moreover, while traces of the frequently erotic character of Surrealist painting pervade his work through the vague references to female genitalia, these allusions are muted, subsumed within an overall abstract composition.

Greenberg, who had once touted Cubism as the driving mechanism of modernist art after Cézanne, would by 1948 disavow the movement and state that its 'decline' had finally set in:

If artists as great as Picasso, Braque, and Léger have declined so grievously, it can only be because the general social premises that used to guarantee their functioning have disappeared in Europe. And one sees, on the other hand, how much the level of American art has risen in the last five years, with the emergence of new talents so full of energy and content as Arshile Gorky, Jackson Pollock, David Smith ... then the conclusion forces itself, much to our surprise, that the main premises of Western art have at last migrated to the United States, along with the centre of gravity of industrial production and political power.

With Cubism on the wane, and American art perceived as ascendant – its raw, nascent traits sometimes allied with America's new-found might as a superpower – the claim was increasingly made by Greenberg and others that Pollock, Gorky and the sculptor David Smith had developed a wholly unique and independent corpus of work.

By the time of this declaration, Pollock had, in fact, made a stunning breakthrough in his art. In 'Answers to a Questionnaire', a rare statement written on the eve of his 1943 exhibition at Art of this Century, he had stated: 'I don't see why the problems of modern painting can't be solved as well here as elsewhere.' Linking his birthplace of Cody, Wyoming and the West with his role as an aesthetic pioneer, he was driven by an interest in the trail-blazing, inventive dimension of modernism, producing from 1943 onwards bold, unparalleled works that took the New York art world by surprise. Dispensing with the conceptual underpinnings of Cubism and its primary focus on structure, he began to pour and drip, rather than brush, skeins of paint directly onto the canvas, a method yielding non-hierarchical, 'all-over' compositions that completely eliminated any trace of the figure or image. *Cathedral* 1947 (fig.4), for example, with its layered, rhythmic and undulating lines of paint, made no attempt to suggest form or specific narrative content. It emerges as a shimmering visual statement, its combination of grace and violence held in a suspended state. Without any illusion of depth, Pollock manages to impart movement while simultaneously asserting the flatness of the canvas. This ingenious step was one that critics such as Greenberg and

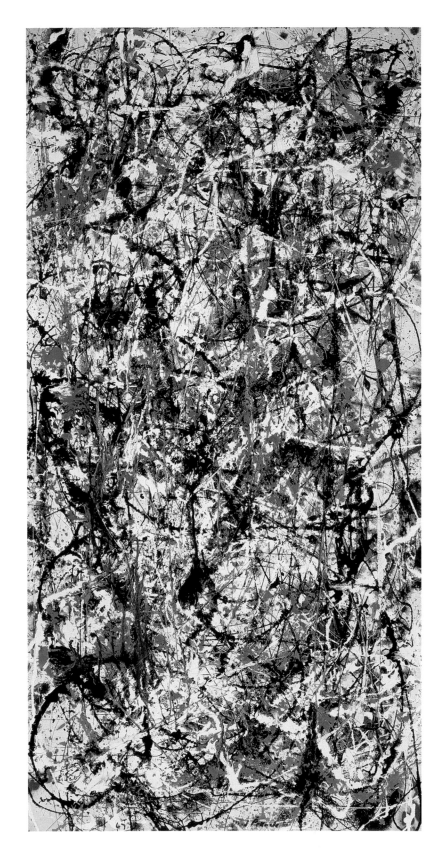

4
Jackson Pollock

Cathedral 1947

Enamel and alumnium
paint on canvas
181.6 × 88.9
(71½ × 35)
Dallas Museum of Fine
Arts, Dallas Texas

Sweeney recognised as unprecedented and far-reaching in its aesthetic ambition.

But Pollock was not the lone innovator in American art in the late 1940s. Other pictorial advances were being made. Clyfford Still, for example, an artist who worked in the Bay area of San Francisco but who had exhibited at Art of the Century in 1947, was motivated by a similar desire to refute, as he put it, those 'ultimatums' of modern art that required one 'to add to the body of references or "sensibility"' that he equated with 'intellectual suicide'. Still, who moved to New York in 1951, became known for his scathing condemnations of much contemporary art criticism (and curatorial practice), including that by Greenberg and his rival Harold Rosenberg. Nonetheless, his repudiation of what he referred to as the 'dogma, authority, tradition' of art reinforced the critical perception that a new movement or trend that differed from European modernism was afoot in New York. Still's defiant, unconventional artistic stance, combined with the singularity of his work, resulted in his immediate assimilation into this new direction. Like Pollock's works, which repressed the primary tenets of Cubism, Still's abstractions of landscapes were devoid of the geometric or structural components of latter-day Cubism that were still being pursued by the American Abstract Artists group. He reformulated the language of modernism by spurning the figure and its embodiment of an external reality. In *1948-C* 1948 (fig.5), for instance, the craggy terrain of a landscape is signified through textured passages of black, white, red and yellow paint. Without means of a representational image, something of the mysterious and sublime aspects of nature are transmitted through this field of alternating colour, providing the viewer with the possibility of a transcendent visual experience.

In 1947, when Coates's term 'Abstract Expressionism' had not yet settled, Barnett Newman – an artist who would also eventually be subsumed within this hazy rubric – mounted an exhibition at the Betty Parsons Gallery in New York. Titled *The Ideographic Picture*, it drew on his own work as well as that of Hofmann, Reinhardt, Rothko, Theodoros Stamos and Still. Newman aimed, like Putzel, both to clarify and elaborate on what he referred to at the time as a 'new force in American painting'. Unlike Putzel, however, he made none of the comparisons to European prototypes, proposing that the work of this assemblage of artists represented 'the modern counterpart of the primitive art impulse'. Newman, who was a native New Yorker, wrote extensively about contemporary art for various commercial galleries and publications before exhibiting his work for the first time in *The Ideographic Picture* show. He was known initially as a polemicist, as someone who contested and questioned the languages, traditions, conventions and subjects of art, and the content of his catalogue essays and articles subsequently shaped the thematic and formal thrust of his work.

During and after this period, Newman produced increasingly austere compositions of a single or reiterated line against a subtly modulated field of solitary colour, as in *Onement 1* 1948 (fig.6). These pictorial reductions, basic and archetypal, prompted Newman's declaration that 'the first man was an artist'. His desire to establish the primal origins of art, to foreground

6
Barnett Newman

Onement 1 1948

Oil on canvas
69.2 × 41.2
(27¼ × 16¼)
The Museum of Modern
Art, New York

creativity as the governing modus of prehistoric cultures, represented an alternative to the pervasive belief that Western Europe was the wellspring of art. This view – international in its scope – not only robbed Paris of its modernist authority but opened the possibility for America, as well as for other countries, to reassess their artistic heritage and legacies.

Newman was an avid student and collector of Northwest Coast native American art. In the abstract patterning of its totems, paintings, baskets and pots, he located aesthetic correspondences with many of the endeavours of contemporary American artists. 'We are freeing ourselves of the impediments of memory, association, nostalgia, legend, myth, or what have you, that have been the devices of European painting', he stated in his 1948 tract 'The Sublime is Now'. 'Instead of making *cathedrals* out of Christ, man, or "life",

7
Barnett Newman

Covenant 1949

Oil on canvas
121.3 × 151.5
(47¾ × 59⅝)
Hirshhorn Museum and
Sculpture Garden,
Smithsonian
Institution,
Washington DC

we are making them out of ourselves, out of our own feelings.' Newman was convinced that in his extreme reduction of art to an 'ideographic picture' of a sublime or quasi-religious state – evoked throughout his work by a ubiquitous line set against an expanse of colour – some primordial connection was made. The *Covenant* 1949 (fig.7), for example, was a re-enactment of an ancient, uplifting and quintessential emotional state. The painting's title, moreover, was a key to its metaphysics.

Newman wished to put forward an alternative view to that expressed by Kootz, Janis, Greenberg, Putzel, Sweeney and Coates, who had tied the work of contemporary American artists to Europe to explain both its pictorial origins and its new formal developments. In the catalogue of *The Ideographic*

Picture, he admonished his peers to write their own history, to frame the trajectory and subjects of their work, declaring: 'it is now time for the artist himself … to make clear the community of intention that motivates him and his colleagues'. His assumption that a 'community of intention' unified the work of artists such as himself, Hofmann, Reinhardt, Rothko, Stamos and Still – artists whom he had grouped together in *The Ideographic Picture* show – added to the growing sense that a shared set of aesthetic convictions had indeed coalesced in New York in the late 1940s. To Newman, this common undertaking took the form of attempting to represent the 'sublime', that is, of infusing art with metaphysical content. In Rothko's *Number 18, 1948* 1949 (fig.8), for instance, the 'sublime' is revealed through the amorphous areas of contrasting colour that seem to hover in an indeterminate space. As in Still's *Untitled* 1945 (fig.9), the suggestion of an incorporeal or otherworldly place is an agent for transcendence, for the viewer to be carried visually beyond the canvas.

A Russian immigrant who grew up in Portland, Oregon, Rothko had been drawn to mythological subjects earlier in his career. Producing luminous watercolours of ancient heroes, gods and vessels, he aimed, like Newman, to retain, as he put it, a sense of the 'archaic' in his work. His painting, especially after he abandoned the figure around 1947, would always emote the tragic, its ethereal shapes the equivalent of a near-religious state.

While Newman's notion of the 'sublime' was aptly applied to his own work, as well as to that of Rothko and Still, the metaphor broke down when it came to figures such as Hofmann and Reinhardt. Not every Abstract Expressionist artist wished to effect the intimation of a primordial or archaic state. While Hofmann had used the word 'spiritual' to describe the sometimes riotous compositional jam that characterised works such as *Apparition* 1947 (fig.10), in which broad swathes of paint appear alongside wandering, frenetic black lines, the calm of Newman's broadly defined fields of colour is distinctly missing here.

But Hofmann, unlike Newman, Rothko and Still, was a German émigré artist whose career unfolded in Paris and later in Munich prior to arriving in New York in 1936. He was steeped in the tradition of European modernism, the work of Picasso, Matisse and Braque, and the idea of tying his painting to an ineffable, extraterrestrial place was antithetical to the more practical, problem-solving nature of his artistic outlook. If any association can be found in his dynamic compositions it is with the undulating rhythms of nature, the ever-changing shape and topography of the earth as well as the constant variability of wind and cloud formations.

Similarly, Reinhardt's *Untitled* 1947 (fig.11), with its dense weaving of biomorphic shapes immersed in a tenebrous, dark space, is far from Newman's notion of the prehistoric fundaments of art. Reinhardt, who studied art history at Columbia University and who later became a founding member of the American Abstract Artists group, believed, like Hofmann, that some of the formal traits of European modernism were worth extending. Both artists still held on to Cubism and its later offshoots as their artistic antecedents. Although Reinhardt's work would by around 1950 adopt a geometric plan,

8
Mark Rothko
Number 18, 1948
1949
Oil on canvas
170.5 × 142.2
(67⅛ × 56)
Vassar College
Art Gallery,
Poughkeepsie,
New York

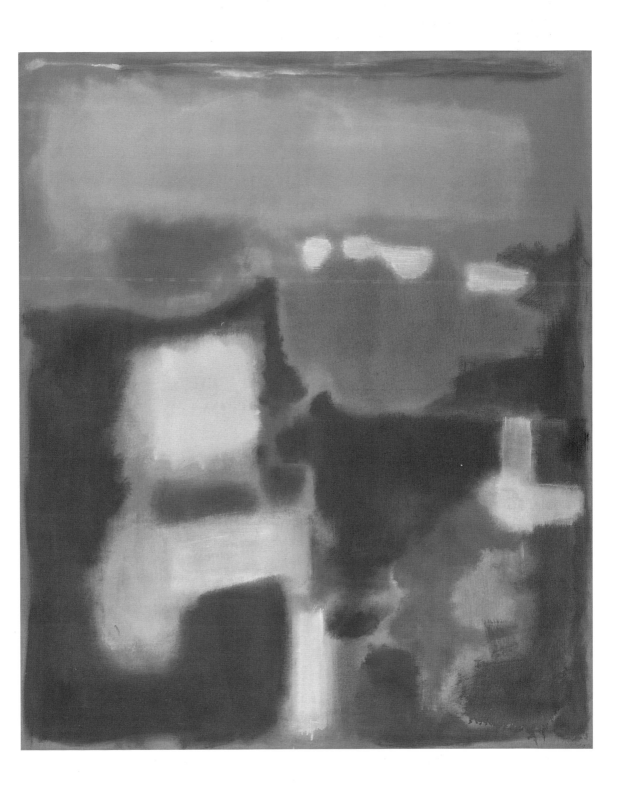

settling into crisp rectangular compartments of one or two alternating colours, which ostensibly suggest the 'sublime' (as in *Abstract Painting, Blue* 1953 (fig.12)), his work is rooted more in what he would refer to as a certain 'timelessness', an immutable, pure state.

Rather than seeing his work as representing a break with the past, Reinhardt situated it in a historic continuum, the stasis and quietude of his

9
Clyfford Still

Untitled 1945

Oil on canvas
107.6 × 85.4
(42⅜ × 33⅝)
Gift of Mr and Mrs
B.H. Friedman.
Collection of the
Whitney Museum of
American Art, New York

severe abstract statements a further expansion of the formal preoccupations of art. He agreed with Newman that art was universal, contending that his goal was ultimately 'to present art-as-art and as nothing else, to make it into the one thing it is only, separating and defining it more and more, making it purer and emptier, more absolute and more exclusive – non-objective, non-

representational, non-figurative, non-imagist, non-expressionist, non-subjective'. But Newman had also placed an emphasis on the artist's subjectivity and interior life in order to impart the 'sublime', features that are absent in this statement. In fact, the repression or denial of individuality is expressed.

With no consensus as to what constituted the defining hallmarks of this new American art, Kootz (now ready to concede that something was actually underway in New York), along with Rosenberg, mounted the exhibition *The Intrasubjectives* in 1949. More expansive than Newman's narrowly focused project, the show accelerated this notion of a movement, of a collective body

10
Hans Hofmann
Apparition 1947
Oil on reinforced
plywood
121.9 × 146.4
(48 × 57%)
Krannert Art Museum
and Kinkead Pavilion,
University of Illinois,
Urbana-Champaign
Festival of Arts
Purchase Fund

of artists with similar goals working in concert. In the mix of work by Baziotes, Gorky, Gottlieb, Morris Graves, Hofmann, de Kooning, Motherwell, Pollock, Reinhardt, Mark Tobey and Bradley Walker Tomlin, Kootz and Rosenberg detected the ingredients of an avant-garde that coalesced around this idea of 'subjectivity', of the artist marking his or her work with aspects of their persona or individuality. But Rosenberg, who would remain continuously averse to nomenclature such as 'Abstract Expressionism', fell short of referring to the group as a school. In fact, in 1947 he had already proclaimed that artists such as Baziotes, Gottlieb and Motherwell were 'attached neither to a community nor to one another'. The conceptual

framework of *The Intrasubjectives*, then, seemed to evolve from the supposition that American art had become an existential act, an emotional outpouring that took on many disconnected forms.

Although Rosenberg, like Greenberg, Sweeney and Coates, was convinced that the American avant-garde had become, due to the German Occupation of France, cut off from Paris, he distanced himself from the nationalism that had quickly come to inform Greenberg's theoretical outlook. As early as 1940, in 'The Fall of Paris', an essay written for *Partisan Review*, he maintained that 'in the "School of Paris", belonging to no one country, but world-wide and world-timed and pertinent everywhere, the mind of the twentieth century projected itself into possibilities that will occupy mankind during cycles of social adventures to come'. To Rosenberg, like Newman, the art scene remained an international culture, the 'modern' representing an intellectual construct and ethos that could not be restricted to geographic centres. While political and economic forces had contributed to Paris's demise, the dispersion of its artists and writers, and their relocation to New York, signified just another permutation or 'cycle' of a by now ruptured modernist history.

11
Ad Reinhardt

Untitled 1947

Oil on canvas
101.6 × 81.3
(40 × 32)
National Gallery of Art,
Washington. Ailsa
Mellon Bruce Fund and
gift of The Circle of the
National Gallery of Art

12
Ad Reinhardt

Abstract Painting, Blue
1953

Oil on canvas
50.8 × 40.6
(20 × 16)
Yale University Art
Gallery

Greenberg had based his announcement of Cubism's 'decline' on the notion that contemporary French art had devolved into a series of decorative 'refinements' to the stylistic vocabulary of modernism. His critical analysis now hinged, ironically, on the formal attributes of art, brushing aside its content, metaphors and resonant subjectivity. Unlike Rosenberg's existential priorities and Newman's focus on the 'sublime', Greenberg's interest in advancing what he perceived as the new superiority of American painting pivoted on its pronounced originality and elimination of the picture plane. An inherent 'purity' characterised the work of Pollock and others, he believed, through its compositional flatness and 'over-all evenness'. Where he had once

declared Jean Dubuffet to be 'one of the major painters of the twentieth century', he now believed that Pollock was 'capable of more variety than the French artist [and] had more to say in the end'. At stake was the 'element of risk' embodied by Pollock's brash refusal to comply with the tradition of Cubism.

In a work such as *Autumn Rhythm* 1950 (fig.13), Pollock's animated skeins and drips of paint had long since ceased to be dependent on the human form. To Greenberg, this astounding invention (the first such advance by an American artist) was no longer tethered to visual precedent. Even an artist such as Mark Tobey (who resided in Seattle but had exhibited in New York throughout the 1940s, and whom Greenberg had once championed) could not compare with Pollock's compositional prowess. Greenberg had acclaimed the innovative traits of works such as Tobey's *New York* 1944 (fig.14), in which an intricate

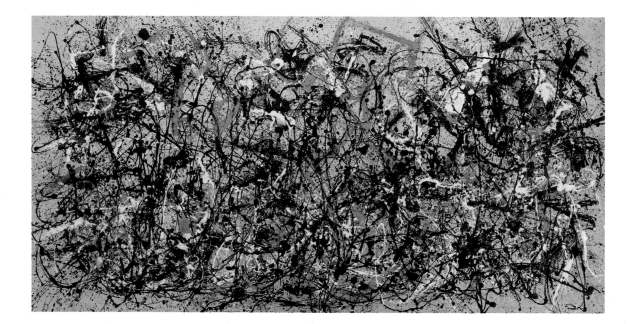

network of tiny white lines dispenses with any hierarchical arrangement. He now believed, however, that these markings smacked of the Swiss modernist painter Paul Klee. With the emergence of Pollock, Tobey's work was perceived by the critic as too 'narrow' and 'confined'. Whatever the singularity of Tobey's expression, he was now passed off as an insular and outmoded figure. But such was the fate of numerous artists engaged in avant-garde issues in the late 1940s. As the quest to define the authenticity of a new American art accelerated around this time, seemingly mounting into a race, the politics of exclusion rapidly set in, steeped in critical zeal, arrogance and a defiant nationalism.

13
Jackson Pollock

*Autumn Rhythm
(Number 30)* 1950

Oil on canvas
266.7 × 525.8
(105 × 207)
The Metropolitan
Museum of Art, New
York, George A. Herne
Fund, 1957

14
Mark Tobey

New York 1944

Tempera on
paperboard
83.7 × 53.2
(33 × 21)
National Gallery of Art,
Washington. Gift of the
Avalon Foundation

2

DO WE ARTISTS REALLY HAVE A COMMUNITY?

In 1949, the year *The Intrasubjectives* exhibition took place at the Kootz Gallery in New York, Baziotes, Motherwell, Rothko and the sculptor David Hare founded the short-lived school 'Subjects of the Artists' at 35 East 8th Street. While the project lasted for only one semester, it was nevertheless significant; the title in itself is fraught with meaning, alluding to a shift in artistic priorities. That the pedagogical approach should centre on 'subjects' as a method of instruction – as opposed to facility, means and skill – underscored a new aesthetic criterion.

Alongside the 'Subjects of the Artists', Motherwell also sensed that many artists in the city shared enough like interests to warrant his coining of the collective term the 'New York School', for a grouping that he believed cohered less around issues of style than around common thematic threads and shared ideological convictions. Unlike Greenberg, who had begun to advocate a closed, nationalistic history, Motherwell saw the New York School as yet another iteration of modernism, its forerunner existing in Paris. The American variation, however, was significantly different, since the idea of the 'self' now became foregrounded as the cornerstone and mainstay of artistic expression.

Motherwell, who studied philosophy as a graduate student at Harvard University before moving to New York in 1940 to pursue art history at Columbia University, become the editor of the renowned *Documents of Modern Art* series in 1944. As an active contributor of essays and reviews on various modernist topics to numerous publications such as *Partisan Review* and the

15
Barnett Newman

Concord 1949

Oil on canvas
228 × 136.2
(89¾ × 53⅝)
The Metropolitan
Museum of Art, New
York. George A. Hearn
Fund, 1968

New Republic, he quickly became known as an erudite, serious thinker in addition to emerging as a formidable painter. Even though his painting was distinctly non-illusionistic from the outset, he was initially drawn to Surrealist artists such as Miró, and would always retain something of the poetic overtones of that artist's work through his oblique referencing of tragedy and war.

In a noted lecture delivered in Provincetown, Massachusetts in 1949, Motherwell drew on the 'self' as a trope to interpret the present state of modernism, announcing: 'such selves have existed in French painting for a long time; now they have begun to appear in America, in clusters. This fact fills me with excitement, not because I am American, but it is extremely moving to see anyone anywhere rise to a certain level of consciousness.' He subsequently endowed the 'self' with specific meaning, writing soon afterwards: 'What the lesson of the School of New York in particular and of modern art in general

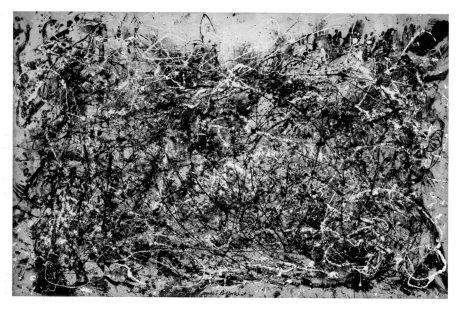

16
Jackson Pollock
Number 1, 1948
1948

Oil and enamel on unprimed canvas
172.7 × 264.2
(68 × 104)
The Museum of Modern Art, New York

17
Robert Motherwell
The Voyage 1949
Oil on canvas
122 × 238.8
(48 × 94)
The Museum of Modern Art, New York

really means ... is subjectivity and its sensibility, its abstract structural sense rather than its descriptiveness in the external world, its devotion to a language of painting, rather than to its prevailing visions of man.'

Newman, of course, had earlier built subjectivity into his concept of the 'sublime'. Moreover, Rosenberg had made individuality the primary *leitmotif* of his interpretation of the creative act, positing it as the organising theme of *The Intrasubjectives* show. That Motherwell ventured to suggest that this *locus* of signification now constituted a School was yet another spin on a name like 'Abstract Expressionism', but one that was far broader in its implications. Unlike Newman's 'sublime', which was associated with a primordial state, Motherwell's construct of the New York School cut through such rhetorical padding, maintaining that emotion – the reflex of the 'self' – was the all-inclusive topic of art. It also allowed for a greater range of abstract solutions. It could incorporate Newman's terse reductions of planes of colour with their

intermittently situated 'zips' (as he came to call the stripes that articulated all his works, exemplified by a painting such as *Concord* 1949 (fig.15)), along with the gestural lattices and compositional excesses of Pollock's *Number 1, 1948* 1948 (fig.16).

In 1949, America's ever proliferating corporate power structures and entry into the Cold War with Russia brought about feelings of isolation and separateness amongst the New York artists. Not many were willing to admit to an entity such as the New York School. Withstanding charges of solipsism or self-involvement, the artists pursued various forms of abstraction, their originality and inventions ultimately irreducible to any one aesthetic formula. For example, if one takes three typical works painted at roughly the same time by different artists, little formal unity or similarity of stylistic intent is revealed. The broad, quasi-rectangular bands of black, white and ochre in

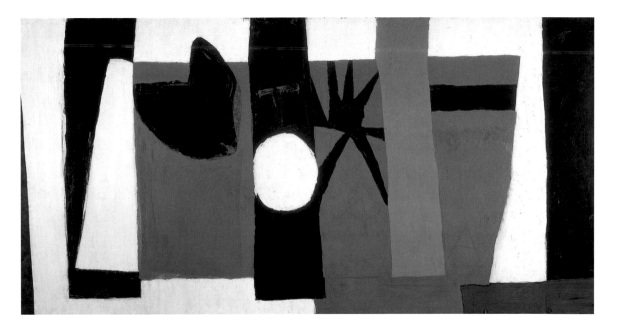

Motherwell's *The Voyage* 1949 (fig.17), painted and repainted to achieve a state of order and balance, contrast with the more scumbled, vapoury surfaces and minimal geometrical shapes in Rothko's *Blue, Green and Brown* 1951 (fig.18), or with the dense combination of fragmented forms that are evenly dispersed throughout de Kooning's *Excavation* 1950 (fig.19). However, the emphasis on subjectivity was generally shared. In fact, a deep preoccupation with existential theory shaped much of the thinking of the artists (and some critics) who became linked with the New York avant-garde. In the single issue of the journal *Possibilities* that Motherwell co-edited with Rosenberg, along with the composer John Cage and architect Pierre Chareau, in 1947–8, the artist and writer declared in their jointly written introduction that 'if one is to continue to paint or write as the political trap seems to close upon him he must perhaps have the extremist faith in sheer possibility'. Motherwell and

Rosenberg deemed that this 'possibility' existed only in the individual 'acts' of the artist, the imprinting, again, of his/her subjectivity on art. However, an increasingly bureaucratic and faceless society appeared to be threatening the expression of individuality, and Motherwell and Rosenberg deemed any acquiescence to artistic convention untenable, possibly even a type of co-option. As they saw it, the only 'possibility' for revitalising art existed in developing the modernist tradition, given its built-in resistance to authority and ongoing renewal of pictorial structures.

While the Subjects of the Artists School was a brief venture, it fuelled the continuing discussion about the content and public reception of contemporary art. With its demise, due to financial problems, its facilities at 35 East 8th Street became the site for an equally fleeting meeting and exhibition space called Studio 35, which was operated by New York University. During its six-month stint, the Friday night lecture programme of Studio 35 became a well-attended and highly successful event, attracting many artists who lived and worked in nearby loft spaces in Greenwich Village. This idea of a community or 'school' was much debated in the weekly gatherings at Studio 35, fostering an eventual three-day symposium that focused on the still lingering issue of an identity and name before it closed in April 1950. Organised by Motherwell and the sculptor Richard Lippold, these sessions were closed to the broader arts community, drawing exclusively on a small group of invited artists including Baziotes, Louise Bourgeois, James Brooks, Herbert Ferber, Gottlieb, Hare, Hofmann, de Kooning, Ibram Lassaw, Norman Lewis, Newman, Richard Pousette-Dart, Reinhardt, David Smith and Hedda Sterne, among others. Only Alfred Barr, the director of the Museum of Modern Art, was admitted from outside of this circle, and his participation was confined to moderating the second-day session.

On the first day of what are now known as the 'Artists Sessions at Studio 35', Newman initiated the discussion, asking 'Do we artists really have a community? If so, what makes a community?' Hare, who had no sense of any mutuality with his peers, replied, 'I see no need for a community. An artist is always lonely. The artist is a man who functions beyond or ahead of his society.' While there was general consensus that the 'self' was the inclusive subject of contemporary art, it was surmised that its individual expression was too varied to amount to an identifiable style. Hofmann's response typified the prevailing sentiment: 'Everyone should be as different as possible. There is nothing that is common to all of us except our creative urge. It just means one thing to me: to discover myself as well as I can.'

But whatever the resistance to solidarity, some artists, like the sculptor Herbert Ferber, would observe that fundamental distinctions now obtained between avant-garde art in America and Europe that were no longer 'a question of geography but of point of view'. This American 'point of view', he proffered, suggested a 'feeling of community' notwithstanding its amorphous state or lack of definition. Ultimately, Hofmann felt that the issue of tradition was at stake, attesting that the American artist 'of today approaches things without basis. The French approaches things on the basis of cultural heritage.' Despite their feelings of stylistic incompatibility and

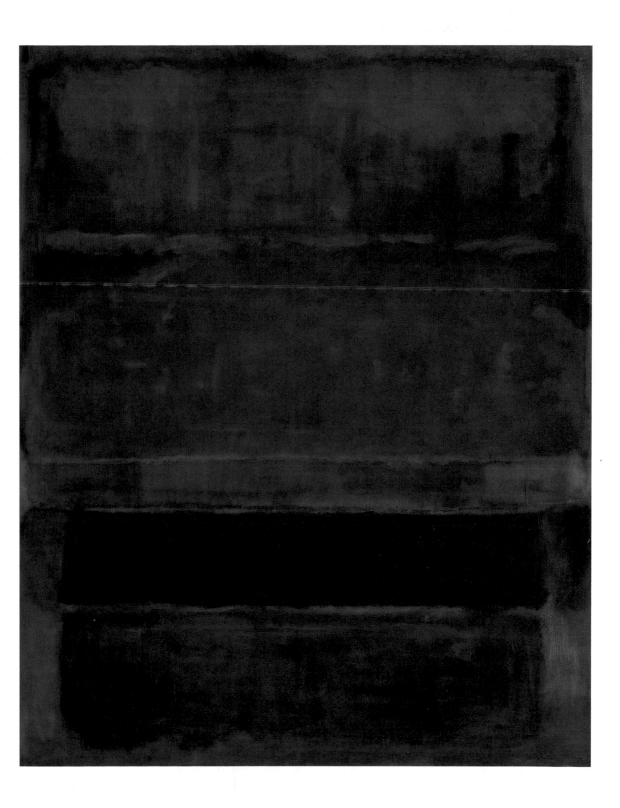

difference, it was generally conceded that the experience of the *tabula rasa* of American culture shaped a certain bond and kinship. The group did not acknowledge the existence of an earlier avant-garde in America, and in the absence of any (perceived) weight of history, most of the assembled artists conceded liberation from pre-existing forms of art.

During the last day of the sessions, the question of a name came up once again. Barr wanted to pin down the group, inquiring, 'What is the most acceptable name for your direction or movement?' Noting the differing

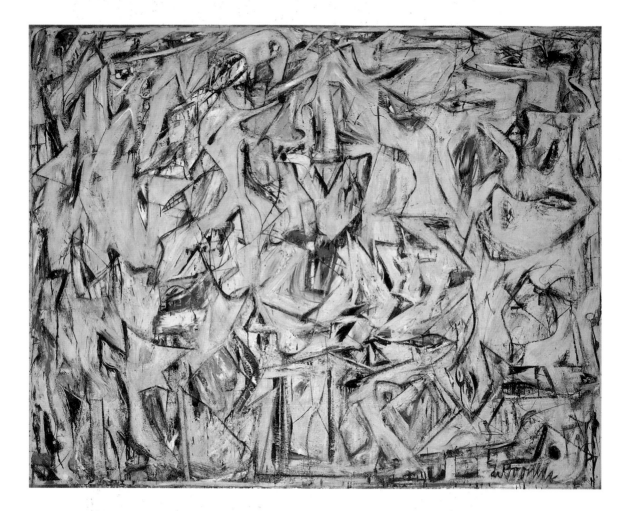

nomenclatures that had been floated in the press to date, he placed the onus on the artists to commit to a term, exclaiming: 'We should have a name for which we can blame the artists — for once in history!' While de Kooning believed, 'it is disastrous to name ourselves', an objection that echoed his ongoing doubt that any artistic collective had even taken shape, Motherwell, more pragmatically, threw out three options for consideration – 'Abstract-Expressionist; Abstract Symbolist; Abstract-Objectionist'. His earlier reference to the 'New York School' would always function as a surrogate and sometimes

preferable epithet to describe the avant-garde movement that had emerged in America after 1945, but 'Abstract Expressionism', without the endorsement of the Artists Sessions at Studio 35, would vie for lasting recognition.

Revealingly, Barr, who had initially disassociated himself from the business of inventing a name, claimed retrospective ownership of the term 'Abstract

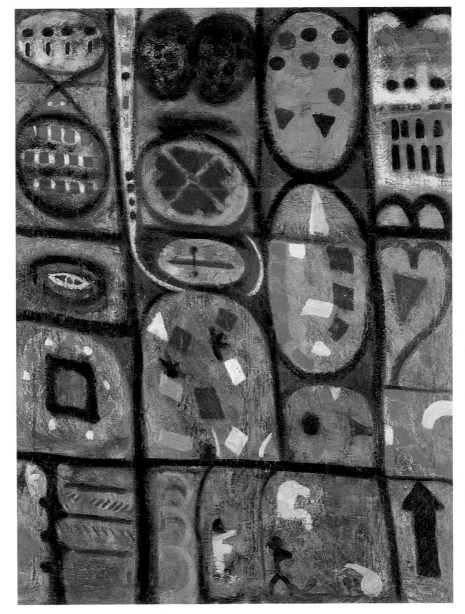

19
Willem de Kooning

Excavation 1950

Oil and enamel on canvas
203.2 × 254.3
(80 × 100⅛)
The Art Institute of Chicago. Mr and Mrs Frank G. Logan Purchase Prize. Gift of Mr and Mrs Noah Goldowsky and Edgar Kaufmann Jr

20
Adolph Gottlieb

Romanesque Façade 1949

Oil on canvas
121.9 × 90.8
(48 × 35¾)
Krannert Art Museum and Kinkead Pavilion, University of Illinois, Urbana-Champaign, Festival of Arts Purchase Fund

Expressionism', stating that he had employed the phrase as early as 1929 in his book to describe the work of Wassily Kandinsky, the Russian artist whom he now believed prefigured much contemporary American art. Barr's interest in becoming the primogenitor of the group's title, in 'getting in on the act', discloses the growing realisation that something fundamentally new,

consequential and far-reaching was afoot in New York in 1950. But was Barr grasping at straws? Kandinsky, after all, had barely been cited by these artists as a direct precursor, even though his work was prototypical in its use of the 'self' as an artistic vehicle. Their visual quotations and influences, when publicly acknowledged, were cited as emanating from a variety of disparate sources such as aspects of Cubism, Surrealism and tribal objects, rituals and painting. There was no trace of the unrestrained, expressive flourishes of Kandinsky's work in Gottlieb's paintings. *Romanesque Façade* 1949 (fig.20), for

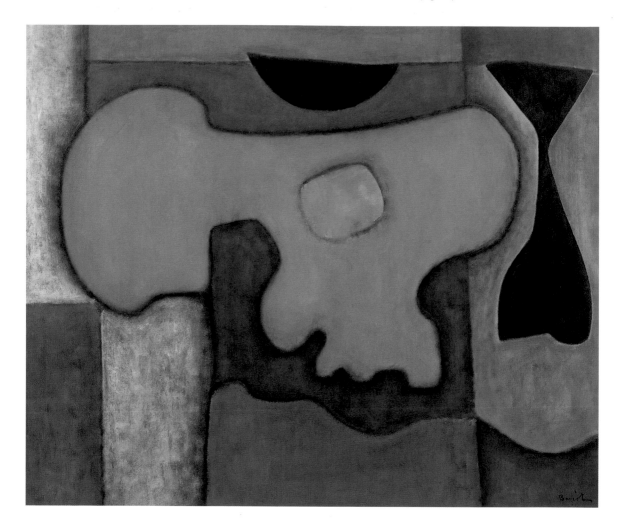

example, in which a grid of boxes contains differing abstract figures, is a 'pictograph' – to use the term with which Gottlieb referred to all of his paintings of this period – that was intended more as an elaboration of pre-modernist architectural imagery. Similarly, Baziotes's works, such as *Green Form* 1945–6 (fig.21), in which a sprawling, organic shape spills into surrounding swatches of muted colours, allude to an inchoate, archaic state.

Gottlieb, like Newman, was one of the few native New Yorkers to be

incorporated into this emergent movement or trend. As an artist who had lived in Arizona in the late 1930s, he believed, as he stated in an article in *Art & Architecture* in 1951, 'that the themes I found in the Southwest required a different approach'. The essentially flat, even disposition of visual elements in *Romanesque Façade* echoes the repetitive features of much Native American art. As a result, the mythic content of the painting becomes woven into and integral to the compositional arrangement. By the same token, Baziotes, an artist of Greek-American heritage who spent his childhood in Reading, Pennsylvania, was consumed with merging ancient myths and new formal solutions.

Though it may have constituted only a generic and distant comparison, Barr's invocation of the Russian artist to confirm his early authorship of the phrase 'Abstract Expressionism' had the unwanted effect of endowing this new direction in American art with a distinctly European lineage and clear material history. The term 'Abstract Expressionism' was eventually rightfully credited to Coates, given the context of its usage in describing the work of Hofmann, Pollock and others. MoMA, however, would from 1942 to 1963 stage a series of exhibitions dubbed the *Americans*, which were curated by Dorothy Miller and would feature many of the figures associated with the New York School, including Gorky, Motherwell, Pollock, Rothko and Still. Through these projects and subsequent larger thematic shows, an accrued modernist narrative would be imposed on their work, the genealogy of which would begin with Cubism, the core of MoMA's collection.

21
William Baziotes

Green Form 1945–6

Oil on canvas
101.6 × 121.9
(40 × 48)
Gift of Mr and Mrs
Samuel M. Kootz and
exchange. Collection of
the Whitney Museum of
American Art, New York

Towards the end of the third day of Artists Sessions at Studio 35, Gottlieb proposed a political action that would unwittingly contribute to the growing impression of a fully formed group. Dismayed by both the academically weighted composition of a jury that was to select work for an upcoming trio of annual exhibitions titled *American Painting Today – 1950* at the Metropolitan Museum of Art, and their corporate sponsorship by Pepsi-Cola, he advocated that a joint letter be sent to the President of the Board protesting against its 'solid phalanx of academicism and mediocrity'. Once written, its appearance in the *New York Times* (which was sent a copy) induced widespread reaction, spawning the now famous photo published in *Life* magazine of January 1951 (fig.22). The caption given to the photo, 'The Irascibles', was sensationalistic and charged, connoting a rebellious, hell-bent, anti-authoritarian lot – the avant-garde as *enfants terribles*. With Pollock occupying centre stage, a placement that underscored his (presumed) ascendancy within the group, a public image of the Abstract Expressionists or Irascibles was now publicly ingrained and recorded.

Gottlieb, however, later maintained, in an unpublished interview of 1968, that the letter to the Metropolitan Museum, with its collection of signatures, and by implication the off-shoot photo, conveyed a false sense of unity:

I think that's the one and only time that we acted as a group. Otherwise, there was no sense of solidarity; there was no ideology. If there was any sense of solidarity it was just out of a sense of mutual self-protection … like everybody else was against you so we had to stick together a little bit.

As well as the objection to being described as a group, feelings of alienation from an uninformed public, and mistrust of a community of 'staid' museum officials such as those at the Metropolitan Museum of Art (who largely privileged and exhibited the work of figurative painters), became recurring themes that would run through their discourse. As Norman Lewis, a member of Studio 35 who attended the Artists Sessions, observed: 'People no longer have this intimacy with artists, so that the public does not know what is going on, what is being done by the painter.' The specialised and remote aesthetic language adopted by the museum was thought by these artists to be an insulating barrier against public appreciation. Yet, from this secluded position some semblance of a common undertaking was moulded.

The list of signatures in the letter of protest to the Metropolitan Museum was purposefully divided by the artists into painters and sculptors, a feature that subsequently resulted in the conspicuous absence of any sculptors in the 'Irascibles' photograph. The museum aimed to showcase contemporary painting in the exhibitions, and the omission of sculpture appeared to the artists to point to an underlying curatorial bias. This 'academic' array of art seemed to be orchestrated around the overriding assumption that painting was the primary or dominant means of contemporary visual expression. Most of the Abstract Expressionist artists, by contrast, abided by a more homogeneous view of the two disciplines. Motherwell had, after all, worked with both Hare and Lippold in launching the Subjects of the Artists School and Artists Sessions at Studio 35. But it was not only the Metropolitan Museum that adopted this circumscribed take on the state of contemporary American art; its position on sculpture, ironically, was shared and upheld by critics such as Greenberg, who came to profess a 'resistance to the sculptural'. Singling out David Smith as a 'notable exception', Greenberg believed that the medium had become afflicted by 'artiness', by which he meant an inability to transcend its materials.

In works such as *The Royal Bird* 1947–8 (fig.23) and *Hudson River Landscape* 1951 (fig.24), Smith worked to counter the conventions of sculpture by down-

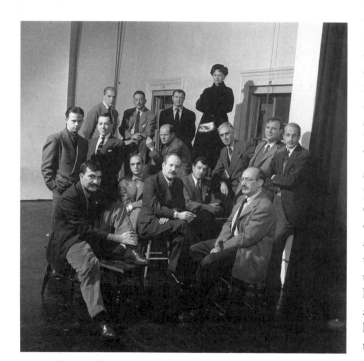

22
Nina Leen's photograph captioned 'The Irascibles' in *Life* magazine, 15 January 1951

23
David Smith

The Royal Bird 1947–8

Steel, bronze and stainless steel
56.2 × 149.9 × 21.6
(22⅛ × 59 × 8½)
Collection Walker Art Center, Minneapolis. Gift of the T.B. Walker Foundation, 1952

24
David Smith

Hudson River Landscape 1951

Welded painted steel and stainless steel
126.8 × 187.3 × 42.1
(49⅞ × 73¾ × 16½)
Collection of the Whitney Museum of American Art, New York

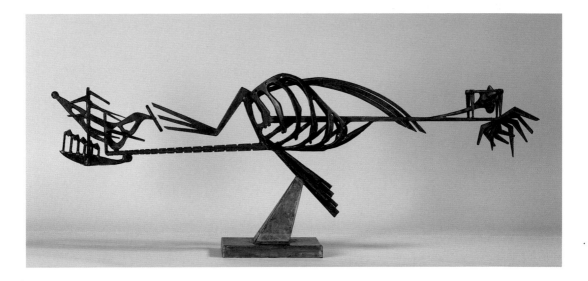

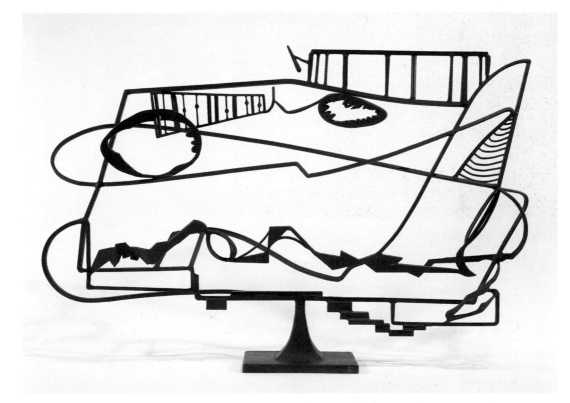

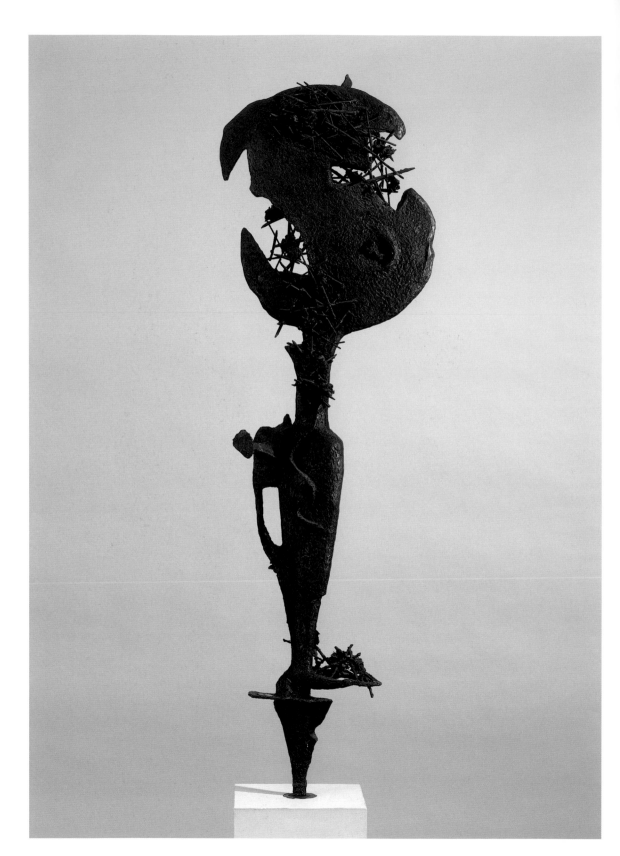

playing and defying its inherent occupation of space. The essentially flat, compressed surfaces of these frontally aligned welded-steel constructions echoed the compositional characteristics of painting. This was a feature that Greenberg read as both subversive and intrinsically novel. While Ferber's *He is*

25
Herbert Ferber

He is not a Man 1950

Bronze cast with
metal rods
170 × 49.5 × 34
(67¼ × 19½ × 13⅜)
The Museum of Modern
Art, New York. Gift of
N.M. Rubin

26
David Hare

The Dinner Table 1950

Welded steel
228.6 × 158.8 ×
120.7
(90 × 62½ × 47½)
Grey Art Gallery, New
York University Art
Collection. Gift of John
Goodwin, 1966

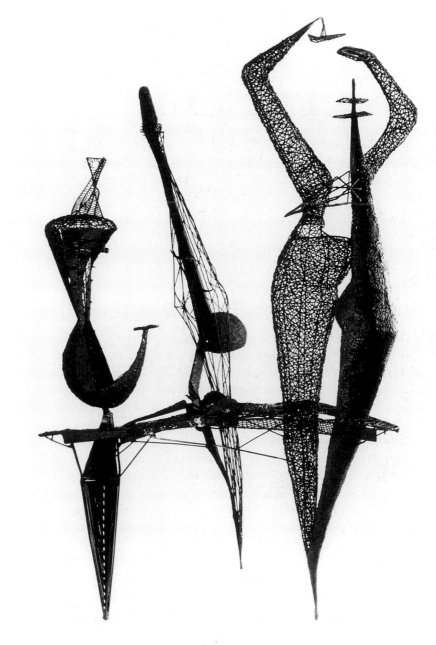

not a Man 1950 (fig.25) and Hare's *The Dinner Table* 1950 (fig.26) are equally abstract, offsetting any overt anthropomorphism or allegory, their involvement of craft and interest in materials were considered by some critics, including Greenberg, as too fussy, an impediment to art's ultimate desire for purity.

that seized on what he perceived as Greenberg's arrogance:

It is assumed that we consider you 'cultural barbarians' because we criticised a single
exhibition of paintings which makes no explicit claims to being a representative anthology
of American art. Anyway, if our criticisms of your painters are the consequence of our
'resentment' against our 'economic dependence' upon you, your worries will soon be over
so far as England is concerned; for after 1952 we shall need no more Marshall aid, and
then we shall give your art its due.

Greenberg had made no mention of the Marshall plan or 'economic
dependence' in his comeback, but his patriotism was clearly overbearing.
Sylvester eventually did give American art 'its due', being one of the first
British critics to embrace Abstract Expressionism, and acclaiming Pollock's
'handling of paint and organisation of colour ... as subtle, as magisterial as
Matisse's or Bonnard's' in a review of a one-person show at the Whitechapel
Gallery in London in 1958. Greenberg's criticism, on the other hand, would
largely remain partisan and one-sided.

Other British writers such as Denys Sutton, who had travelled to New York
in 1949 to assess the beginnings of an American scene, commented that
'though the majority of [American] painters are still of secondary importance
it is difficult to resist the feeling that the artist in America is filled with
confidence and is about to scale the heights'. But as the work of American
artists began to be exported for exhibition abroad, these early optimistic
prognostications receded. The tentative yet sympathetic reading of American
art and its future by foreign critics such as Sutton was fast overcome by a
certain chauvinism, which meant that the Abstract Expressionists were either
whole-heartedly touted or passed off as upstarts. While Sylvester was able to
surmount such incipient flag-waving, the French writer Michel Seuphor, who
visited New York in 1950 and who was otherwise enthralled by the city's
cultural vibrancy, was left feeling that:

Today Paris maintains a very great prestige in the eyes of most Americans, but the
opinion is that their young painters equal ours. Certain individuals, lightly tinged with
nationalism, go so far as to say that their painters are much stronger than those of blood-
drained Europe, a senile continent doddering to its end. They are wrong.

The battle for artistic leadership, ironically, only contributed to a growing
sense of isolationism in both New York and Paris.

But who started the critical warfare? What were its critical origins? As we
have seen, the nationalistic rhetoric that reached its peak around 1950, and
which characterised mainstream interpretation of American art throughout
the decade, was largely induced by the need to dissociate and wean Abstract
Expressionism from an extraneous association with Cubism. And therein
developed some of the aesthetic rivalry and patriotism that raged on both
continents. Greenberg was one of the most overt and zealous US proponents,
demeaning an exhibition of contemporary French artists at the Whitney
Museum of American Art in 1947, as 'shocking ... Its general level is, if

anything, below that of the past four or five Whitney annual exhibitions of American painting.' Apart from the ongoing praise that he would always reserve for Dubuffet, one of the artists included in the show, his exclusive allegiance to Abstract Expressionism was clearly determined by this time.

Some French artists such as Georges Mathieu were mystified and hurt by the reaction to contemporary Parisian art in New York. In 1952, following an overlooked exhibition in New York by the German-French artist Franz Wols, he sent an open letter addressed to 'Twenty-Five American Artists': 'I have been very surprised to hear', he wrote, 'that in New York you had not immediately recognised Wols as one of the most worthy brothers, the Rimbaud of Painting. I do not want to believe that a narrow-minded nationalism has anything to do with the reserve you showed at the time of his exhibit.' But not every critic's writing was wrapped in patriotic fervour. Those who looked beyond formalism for ways to explain the new American painting and sculpture were largely uninterested in challenging French artistic authority. Rosenberg and Motherwell, for example, had earlier highlighted individuality as the *modus operandi* or true subject of art in their issue of *Possibilities*, a declaration that evolved into *The Intrasubjectives* show at the Kootz Gallery. However, as Greenberg emerged as the dominant critic, figures like Rosenberg felt pressured to fine-tune their critical positions, endowing their stances with increased specificity and clarity.

By 1952, with Pollock thoroughly established as the doyen of American painting, a role that had been assisted by Greenberg's critical bolstering, Rosenberg questioned the investment of such clout in one artist, as well as (yet again) the inadequacy of terms such as 'Abstract Expressionism'. In his most celebrated essay 'The American Action Painters', published in *Art News* in December 1952, Rosenberg devised a new discursive frame for post-war American art. He noted that 'What makes any definition of a movement in art dubious is that it never fits the deepest artists in the movement — certainly not as well as, if successful, it does the others. Yet without the definition something essential in those best is bound to be missed.' Without naming Pollock, or any other artist, Rosenberg proposed that art should be considered less in terms of its intrinsic compositional attributes and the audacity of its inventions than with regard to the degree of subjectivity present in the work. In a much-quoted adage from the essay, the 'canvas is an arena in which to act', Rosenberg attempted to tilt the emphasis towards the process of painting, in the sense that it constituted the outpouring of the artist's subjectivity.

Rosenberg believed that, while impossible for the viewer to recreate and pin down exactly, something of the existential plight of the artist was conveyed in the abstract swathes and skeins of paint that were unleashed on the canvas. When the article appeared in *Art News*, Pollock claimed to be the author of the word 'action', believing that Rosenberg was alluding to his extremely active form of painting in devising a new interpretative scheme for post-World War II American art. But the critic actually had de Kooning in mind. In works such as *Woman 1* 1950–2 (fig.27), in which a figure is realised out of forcefully applied sweeps of paint, Rosenberg felt that the hallmarks of de Kooning's individuality were abundantly evident. Moreover, he believed de Kooning had

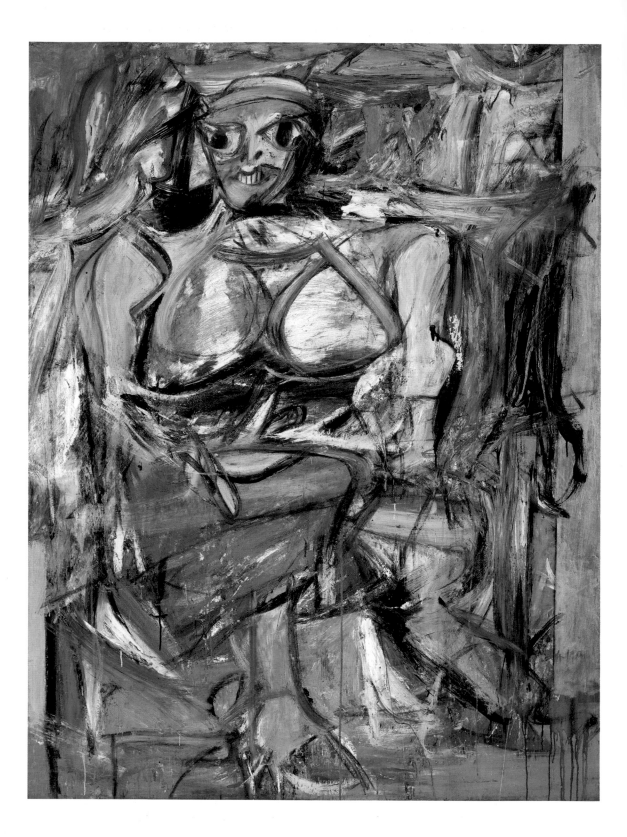

waited too long for recognition, unnecessarily overshadowed by Pollock's considerable public exposure and critical acknowledgment.

De Kooning, who grew up and studied in Rotterdam before moving to the United States in 1926, never entirely gave up on the figure. In fact, he intermittently pursued the female form as a subject from 1938 well into the early 1950s. Unlike Pollock, he remained essentially respectful of artistic tradition, believing that its core subjects still remained viable. However, he also knew that art history was a fluid, mutable mechanism, one whose vitality issued from constant stylistic revision. While the body might have sustained his attention as genre or topic, it also served as a structure on which to project aspects of his ego or originality.

Rosenberg hoped that 'The American Action Painters' would shatter the centrality of Pollock's place in the New York School, his primary goal being to provide a more even-handed, analytical tool that would accommodate the work of the myriad figures associated with this new avant-garde movement. The phrase 'Abstract Expressionism', he believed, was too limited in its scope and designations. His surrogate term 'Action Painting' stuck for a long while, used interchangeably with 'Abstract Expressionism' as the 1950s wore on and the work of de Kooning, Gorky, Pollock and others gained in visibility. With its resonant Romantic overtones – connoting an image of the artist working alone in his studio, 'acting' out his individuality – the phrase 'Action Painting' was anathema to Greenberg, however, who felt his authority challenged. 'The American Action Painters' had fast become a highly influential tract, read as an alternative to formalist interpretative models. After 1952, the essay spawned a deep-seated rivalry between the two writers, which would be sustained for well over a decade.

27
Willem de Kooning
Woman I 1950–2
Oil on canvas
192.7 × 147.3
(75⅞ × 58)
The Museum of Modern Art, New York

28
Willem de Kooning
Seated Woman 1952
Pastel, pencil and oil on two hinged sheets
30.8 × 24.2
(12⅛ × 9½)
The Museum of Modern Art, New York

Greenberg had earlier declared in the *Nation* that de Kooning's work lacked 'the force of Pollock or seriousness of Gorky, more enmeshed in contradictions than either, [he] has it in him to attain to a more clarified act and to provide more viable solutions to the current problems of painting'. His reservations centred on the lingering trace of the figure in de Kooning's work, a 'contradiction' or drawback that impeded, he believed, the systematic progress of abstract art. In *Seated Woman* 1952 (fig.28), for example, the wide-eyed, ponderous stare of the subject is the focus of our attention; the sheaths of paint that define her body remain secondary. To Rosenberg, the presence

of an identifiable figure in de Kooning's work was immaterial. The essential content, after all, was the artist's interiority.

Unlike the fixed specifications that Greenberg brought to bear on the work of the Abstract Expressionists, Rosenberg's thinking was more elastic and not tied to any one medium. The title of 'The American Action Painters' was, in fact, a bit of a misnomer, since painting was not the exclusive domain of his interest, unlike Greenberg's. As well as artists such as de Kooning, Gorky, Hofmann and Newman, who became woven into his writing and eventually the subjects of his monographic studies, Rosenberg also reviewed and wrote about American photography and sculpture. The photographs of Aaron Siskind, which had been exhibited alongside the work of Rothko, Newman and Still at the Betty Parsons Gallery in the late 1940s, would become part of his interest. He linked Siskind's independent, personal aesthetic stance to the abstract designs of the painters in the show. In *Chicago 4C* 1948 (fig.29), for instance, Siskind presents the degraded paint and plaster of an innocuous wall as a fleeting passage of beauty. By suppressing the realism traditionally associated with photography, Siskind, much like the Abstract Expressionist painters, had imprinted his work with aspects of his personality.

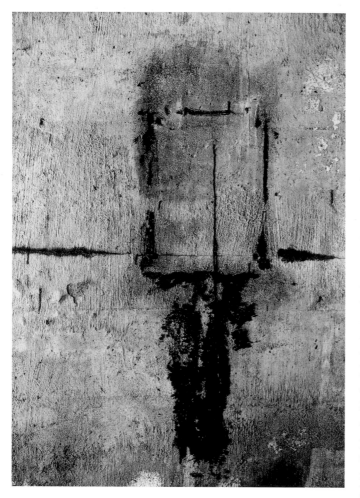

29
Aaron Siskind

Chicago 4C 1948
Gelatin silver print
35.6 × 27.9
(14 × 11)
The Museum of Contemporary Art, Los Angeles. Gift of Marjorie and Leonard Vernon

30
Jackson Pollock

Portrait and a Dream 1953

Oil on canvas
148.6 × 342.2
(58½ × 134¾)
Dallas Museum of Fine Arts, Dallas

As the 1950s came to a close, and after Pollock had become established as the foremost artist of his generation, Rosenberg questioned his primacy more pointedly, eventually mocking Pollock by referring to him as either 'Daniel Boone' or 'Buffalo Bill'. He thought that too much mythology had been spun from the descriptions of Pollock's pioneering spirit by Greenberg and others,

overshadowing the aesthetic inroads made by numerous other artists. Greenberg had in fact disavowed Pollock's work around 1951–2, at a moment when the artist had reintroduced quasi-figurative shapes into his paintings, as in *Portrait and a Dream* 1953 (fig.30). (The silhouette of a face here, however veiled by meandering lines of paint, was not an element that Greenberg could incorporate into his visual theory.) But Pollock's pre-eminence was by now entrenched and irreversible, secured by a younger generation of critics and curators who continued to add to his soaring reputation and celebrity. With Pollock now represented as the major 'action' painter or Abstract Expressionist artist, Rosenberg could only regret that, 'Willem de Kooning, Franz Kline, Hofmann, Guston, Tworkov … and dozens of others in the United States, England, Holland, Italy, Japan [have] become disciples of the muse of the Rocky Mountains.'

Greenberg had essentially construed formalism as a new objective critical method with which to trace the successive unravelling of styles in art. Within

this continuum, the historic development of abstraction in painting, he believed, was immanently readable. But Greenberg's own idiosyncrasies and taste ultimately crept into this purported empiricism. For example, Philip Guston was an artist omitted from his schema, a deletion that is hard to reconcile with the formalist prerequisite for flatness and purity. Guston's *For B.W.T.* 1952 (fig.31), for example, upholds the same rigorous abstract standards as those championed by other artists of his generation, its graceful brushwork configured into a net of soft, lyrical colour. Similarly, the work of Bradley Walker Tomlin (to whom Guston's painting was dedicated), was expunged from Greenberg's discourse on the New York School. Tomlin's *Number 10* 1952–3 (fig.32), which is made up of bold, non-referential black and white marks set in a grid is an 'all-over' composition that dispenses with hierarchy.

Guston would eventually become disaffected with formalist theory, contending in 1960, 'There is something ridiculous and miserly in the myth we inherit from abstract art: that painting is autonomous, pure and for itself, and

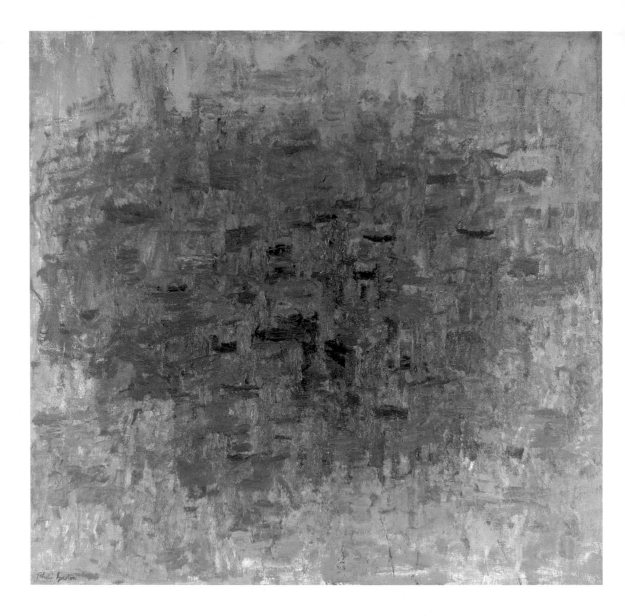

therefore we habitually analyse its ingredients and define its limits. But painting is "impure". It is the adjustment of "impurities" which forces painting's continuities.' Abstract Expressionist painting and sculpture were filled with contradictions, Guston implied, ripe with diverse subject matter that was too often critically ignored. From Newman's 'sublime' numinous landscapes through to de Kooning's figures of women, and Pollock's outpouring of his 'unconscious', as he referred to the content of his work, a panoply of themes made up the collective body of work of the New York School. Occasionally, as in Motherwell's *Elegy to the Spanish Republic No.34* 1953–4 (fig.33), with its overblown, black phallic imagery, the title is embedded with trenchant political meaning, a reminder that most of these artists viewed their abstractions as a principled statement, a stance against tyranny and against

31
Philip Guston

For B.W.T. 1952

Oil on canvas
123.2 × 130.8
(48½ × 51½)
Collection Jane Lang
Davis, Medina,
Washington. Courtesy
of McKee Gallery,
New York

32
Bradley Walker Tomlin

Number 10 1952–3

Oil on canvas
182.9 × 260.4
(72 × 102½)
Munson Williams
Proctor Institute
Museum of Art, Utica,
New York

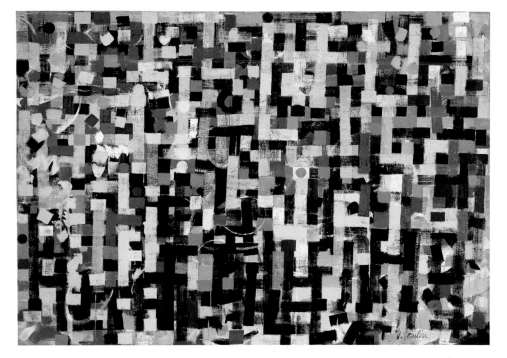

what they viewed as the erasure of the independent voice by both government and the rapid onset of global capitalism. Guston felt that the concept of 'purity' did not sufficiently represent the ethos of the Abstract Expressionists. However, Greenberg never heeded the aesthetic utterances or convictions of artists, declaring: 'I don't think I quote living painters. And I don't pay any attention to what they say in connection with their art.'

The narrowness of formalist criticism, and its inability to incorporate a wide spectrum of artists into its orbit, ironically contributed to the ways in which Abstract Expressionism was framed well into the late 1960s, both nationally and abroad. The flaws and shortcomings of the term would continue to be addressed, eventually spawning two stylistic subdivisions within the group. As the works of Guston, Tomlin, James Brooks and Franz Kline

veered towards total abstraction in the late 1940s, relinquishing any fragment of the figure, they became identified under the heading of 'gestural abstraction'. A subset of Abstract Expressionism, 'gestural abstraction' was meant to connote the bold brushwork that had first appeared in the canvases of de Kooning, Hofmann, Motherwell and Pollock. The counterpart of this direction was dubbed 'colour-field painting', a phrase that incorporated the contained and luminous work of Newman, Rothko and Still. This bifurcation provided some sense of clarity and stylistic order. For example, Rothko's

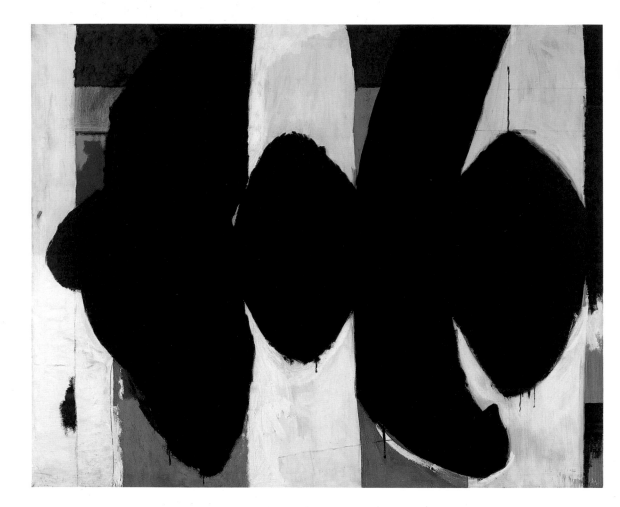

ethereal *Light Red over Black* 1957 (fig.34), with its two mute, diaphanous black squares immersed in a red expanse of colour, is contrasted and offset by the muscular black and white swaths of paint that comprise Kline's *Buttress* 1956 (fig.35).

Kline, who was raised in Wilkes-Barre, Pennsylvania before studying art in Boston and London, had earlier painted gritty, realistic scenes of the coal mines and cities that surrounded his childhood environment. However, these themes gradually eased into robust abstractions that were influenced by his

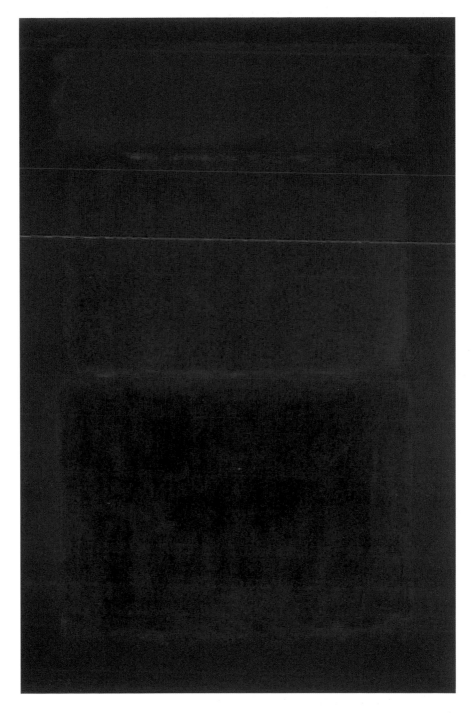

33
Robert Motherwell

Elegy to the Spanish Republic No.34
1953–4

Oil on canvas
203.2 × 254
(80 × 100)
Albright-Knox Art
Gallery, Buffalo,
New York. Gift of
Seymour H. Knox,
1957

34
Mark Rothko

Light Red over Black
1957

Oil on canvas
232.7 × 152.7
(91⅝ × 60⅛)
Tate

study of Japanese art around 1943, the year he met de Kooning and Pollock in New York. Kline developed deep friendships with both artists, sharing their interest in the gestural, expressive potential of painting.

Whatever the internal sorting and differences, the umbrella term 'Abstract Expressionism' prevailed in the end, eventually supplanting Rosenberg's 'Action Painting', with all its performative and physical significations. When MoMA mounted a huge exhibition titled *The New American Painting*, which travelled to

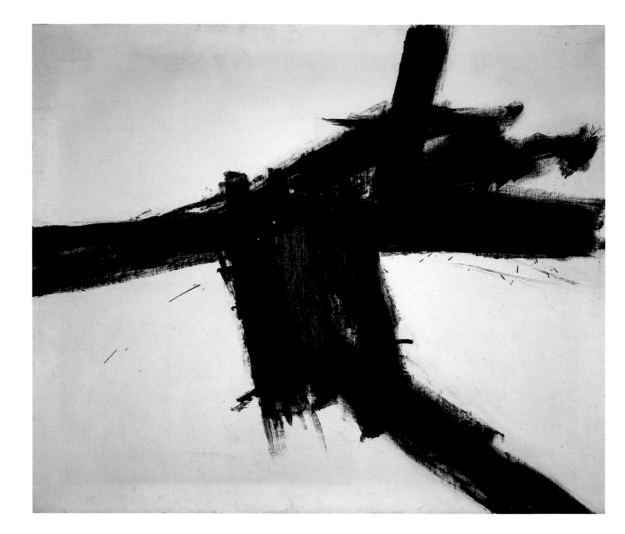

eight European cites in 1958–9, Barr, in his introduction to the catalogue, retracted his earlier claim to the phrase, writing: 'the painters in this show deny that their work is "abstract", at least in any pure, programmatic sense; and they rightly reject a significant association with [Kandinsky] and German Expressionism, a movement recently much exhibited in America'. The project represented the first major exportation of contemporary American art abroad. Along with established figures — artists who represented, as Barr put it, 'the central core' — such as Baziotes, de Kooning, Gorky, Gottlieb, Guston,

Hofmann, Kline, Newman, Pollock, Rothko, Stamos, Still and Tomlin, members of a younger generation of painters who extended the language of abstraction such as Sam Francis, Grace Hartigan and Jack Tworkov were also included. Referring to the latter as 'major marginal talent in the movement now generally called "Abstract Expressionism", or less commonly, "Action Painting"', he was unsure how to depict the state of the American avant-garde, noting the stalwart reluctance of these artists to admit to 'a school'.

The inclusion of Francis, Hartigan and Tworkov revealed that by the late 1950s Abstract Expressionism had acquired a certain continuity and had begun to exert its influence. This second generation of Abstract Expressionist artists reworked and enlarged many of the formal ideas first advanced in the painting of de Kooning and Pollock. Francis's *Painting* 1957 (fig.36), for example, with its gossamer washes and drips of loose, unfettered paint, restated many of the visual traits of 'gestural abstraction'. Tworkov's *Sea Play* 1958 (fig.37) reiterated its sense of expressive urgency and unease. Barr's oxymoron of 'major marginal talent' perhaps underlined the over-dependence of these younger artists on a body of pre-existing forms, now recast and somewhat mannered, a sign of the aesthetic hold that the 'central core' of artists exerted on subsequent developments in American art. While originality had once been the thrust of the New York School, it became less crucial and pressing in the hands of these artistic successors.

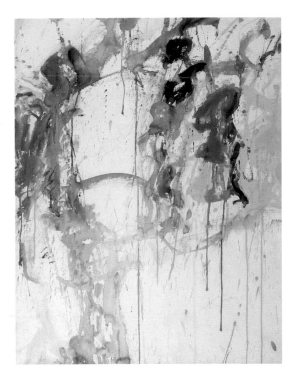

Recalling the reception of the works by de Kooning, Gorky and Pollock in Venice in 1950, *The New American Painting* exhibition incited widespread but mixed reaction as it toured Britain and Europe. However, whatever the individual critic's position, the reviews were now for the most part fused with a familiar patriotism and intense fervour. While some critics such as Will Grohmann, who covered the show for *Der Tagesspeigel* at the time of the Berlin installation (September 1958), contended, 'these young Americans stand beyond heritage and psychology, nearly beyond good and evil', other writers were not nearly so effusive. By contrast, John Berger, writing earlier about the new American art for the *New Statesman and Nation* (January 1956) in London, was deterred by the 'pathological self-deception which claims that the "action" paintings ... have anything to do with art'. These wild critical swings and sectarian differences would continue to typify foreign response to Abstract Expressionism into the late

1960s, raising either the perpetual question of debt to artistic forerunners such as Cubism, or that of a willful violation of tradition.

In New York, other issues and accusations began to impinge on the by now august status of the New York School. Robert Goldwater, who had been writing about the activities and works of these painters from the early 1950s onward, noted that by 1959 The Club, after nearly a decade of lively aesthetic debate, had lost its edge as well as many of its original members, observing: 'At the beginning only those who were known to have anything to do with the authorities were allowed to play; now it is the other way around: most of the

uptown men won't come through the door.' The Club was indeed to fold three years later. Goldwater's reference to the 'uptown men' is telling, a euphemism that speaks of the new-found social and economic status of some of the more prominent Abstract Expressionist artists. De Kooning, for example, now spent most of his time in the Hamptons on Long Island. Newman and Rothko, whose fortunes were poised to pick up, lived and worked on the Upper East Side of New York. And, Motherwell, who summered each year in Provincetown, Massachusetts, would soon move permanently to Greenwich, Connecticut.

Goldwater's allusion to the changed complexion of the New York School, its by now wide acceptance and notoriety and the fact that it has been accepted as a visual movement, revealed that something of its original vitality had consequently been lost. Abstract Expressionism now possessed a history, as well as a 'mythology and hagiography', as he subsequently noted in the journal *Quadrum*, that spawned a second and third generation of 'imitators'. After Pollock's untimely death in 1956 from an alcohol-induced car accident, independent exhibitions of various artists associated with the movement proliferated, along with larger thematic projects such as *The New American Painting* organised by MoMA in 1958. Many critics and artists such as de Kooning pondered at around this time whether this exposure and the multiplication of the styles of Abstract Expressionism through younger artists had not resulted in a 'new academy'.

Rosenberg continued to believe that any evidence of individuality in art was positive, a sign of resistance to bureaucratic entities, such as the government and corporations. He also observed, however, that by 1965 an 'art establishment' had emerged. Writing in *Esquire* (1965) about the art world in general, he noted that the practice of art had now become 'affected by developments outside itself over which it has no control – the condition of the stock market, the change in social moods and attitudes (for example, from revolt to conformity). Museum directors, dealers, critics, artists live with eyes and ears permanently cocked for trends.' Whatever loose sense of community had originally united the New York School in the late 1940s was diffused some twenty years later, its aesthetic defiance and independent spirit now silenced by what was fast becoming the culture industry.

37
Jack Tworkov
Sea Play 1958
Oil on canvas
106.7 × 90.2
(42 × 35½)
National Gallery of Art,
Washington. Gift of
Aaron I. Fleischman

4

38
Barnett Newman
Adam 1951–2
Oil on canvas
242.9 × 202.9
(95⅜ × 79⅞)
Tate

OTHER POLITICS: THE OUTCASTS AND THE OUTSIDERS

Not all of the artists engaged in the Artists Sessions at Studio 35 or the activities of The Club experienced the same acclaim as de Kooning, Motherwell and Pollock. Newman's visibility, for example, was slower in coming. After one unsuccessful solo exhibition at the Betty Parsons Gallery in 1951, which engendered critical condemnation and went without sales, his work languished on the sidelines of critical debate until 1955 when Greenberg deemed that, 'Barnett Newman ... has replaced Pollock as the *enfant terrible* of Abstract Expressionism.' According to Greenberg, paintings such as Newman's *Adam* 1951–2 (fig.38), with its ascetic composition of two red vertical lines set in a brown ground, portended a new direction in art. At the end of the 1950s, he further renewed Newman's authority by identifying the 'contemplativeness' of this work, its rarified abstract beauty and feeling of stasis and calm, as a visual precedent for the paintings of artists such as Helen Frankenthaler and Morris Louis.

Like other artists following on the heels of Abstract Expressionism, Frankenthaler and Louis focused primarily on the formal traits of colour-field painting, expanding its possibilities through staining and sponging paint directly onto their canvases. (There is little critical agreement as to how these artists should be defined or dubbed. They are known variously as second-generation Abstract Expressionists, colour-field painters and post-painterly abstractionists. That the nomenclature at this historic juncture should become so contested reveals the now pedantic and finicky differences in ideological outlook.) Emptied of any specific meaning, unlike Newman's work, with its

Old Testament titles and symbolic tone, their large-scale abstractions were the ultimate manifestation of Greenberg's notion of purity. Frankenthaler's *Mountains and Sea* 1952 (fig.39), for example, with its exposed areas of unprimed canvas amid delicate washes of localised colour, perpetuates the formalist idea that modernist painting was a progressive endeavour, constantly rephrasing and refining its visual properties. As in Louis's *Alpha-Phi* 1961 (fig.40), with its huge, environmental proportions and diagonally splayed lines of stained paint, compositional features are all-determining and paramount, not tethered to a narrative or specific subject. But unlike Newman, Frankenthaler was an artist who attained almost instantaneous success. Such would be the case with many of the second-generation Abstract Expressionist artists. (Louis died at a relatively young age, but the considerable discussion that centred on his work, along with a subsequent proliferation of exhibitions, suggests that he may well have received similarly rapid recognition.) Building on the history of the New York School and a culture increasingly predisposed towards modern art and

its impulses, many of the followers of de Kooning, Newman and Pollock fared somewhat better in terms of critical and material success at the outset of their artistic careers.

By 1959, Newman, however, was fully positioned as an Abstract Expressionist artist, having made a comeback, in part, through Greenberg's revitalisation of his profile. An exhibition that year at French and Company in New York, organised by the writer, did much to secure his place as a major American artist. But this was not the fate of all figures associated with post-war American art. Guston, who had exhibited repeatedly at the Sidney Janis Gallery in New York from the mid-1950s onwards, and whose work was the subject of two major exhibitions at the Solomon R. Guggenheim Museum and Jewish Museum in 1962 and 1966 respectively, taught intermittently until the end of his life in 1980, since the sales of his work were not substantial enough to pursue painting exclusively. Moreover, by 1967–8, he had begun to rethink the whole enterprise of modernist painting, soon declaring, 'I got sick and tired of all of that purity.' At first, this amounted to a critical setback. For the quirky, incongruous cartoon-type images that surfaced in his painting around this date, with their sometimes acerbic political narratives, also doubled as an oblique statement on the failure or collapse of modernism. *Outskirts* 1969 (fig.41), for instance, with its row of hooded Ku Klux Klan figures, violated the high-mindedness and sanctity of abstract painting, sullied not only by

39
Helen Frankenthaler

Mountains and Sea
1952

Oil on canvas
220 × 297.8
(86⅝ × 117¼)
National Gallery of Art,
Washington

40
Morris Louis

Alpha-Phi 1961

Acrylic on canvas
259.1 × 459.7
(101⅞ × 180¾)
Tate

explicit, recognisable imagery but by its purposefully crude pictorial treatment.

Some art critics for mass-media publications, such as Hilton Kramer in the *New York Times*, attempted to write Guston off as a heretic, an artist who had betrayed the cause of Abstract Expressionism. Others, like Rosenberg, however, read the audacity of Guston's late work as a 'liberation from detachment', a necessary re-engagement of meaning and story-telling in art. Revealingly, when New York School artists such as James Brooks and de Kooning saw Guston's paintings of the KKK at their first exhibition in the Marlborough Gallery in New York in 1970, they interpreted them as part of a continuum, the hidden, repressed underside of abstract painting. De Kooning had, of course, periodically employed the figure in his work even after making

the leap into abstraction around 1942. Brooks, like Guston, was a late convert to Abstract Expressionism; having held on to the figure until 1948 he was similarly reluctant completely to repudiate the body as a potent form in art. Paintings such as *Untitled* 1952 (fig.42), with its black, yellow and white all-over composition, suggest a loose debt to Pollock. Yet in Guston's late work he was able to see a profound interconnection with abstract painting and an ongoing elaboration of the language of painting.

However, not much remained of the New York School in 1970, when Guston proclaimed his latent distrust of 'purity' and its formal requirements. Figures such as Baziotes, Hofmann, Kline, Newman, Pollock, Reinhardt, Rothko and Still were all dead by this point in time, and Motherwell had long since moved away from New York. While it was generally conceded that

Abstract Expressionism was spent, superseded by the rise of Minimalism and Pop art in the early 1960s, Guston's work after 1968 signalled the end of the idealism that had driven the movement. Some artists such as Newman had continued to question whether the New York School had existed at all, stating as late as 1965: 'There was never a movement in the conventional sense of a "style", but a collection of individual voices. That is why to talk of the movement being dead is ridiculous.' But the expression of individuality had also ceased to make headway as a subject, replaced by the anonymous, depersonalised, cool aesthetic stance that surfaced in the art of the 1960s, along with the proliferation of what Rosenberg called the 'Art Establishment'.

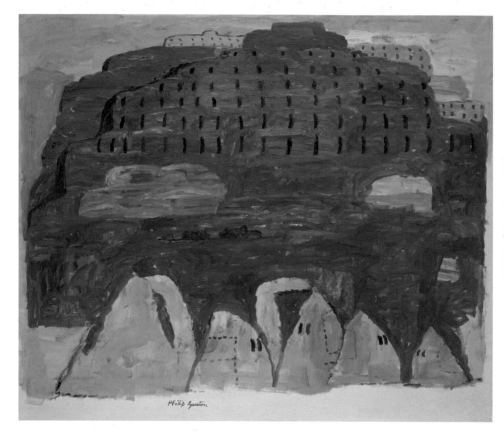

41
Philip Guston
Outskirts 1969

Oil on canvas
161.5 × 190.5
(65 × 75)
The Estate of Philip
Guston. Courtesy
McKee Gallery,
New York

But what became of artists such as Louise Bourgeois, Richard Pousette-Dart, Richard Lippold and Norman Lewis, who had also participated in the Artists Sessions at Studio 35? The fate of Ferber, Hare and Lippold has already been noted; apart from David Smith, few sculptors would be integrated into the ongoing assessments of Abstract Expressionism. Lippold, for example – whose works are exemplified by *Primordial Figure* 1947–8 (fig.43), featuring a delicate web of thin metal wires configured into a quasi-totemic shape – would be overlooked by many of the upholders of formalism as immanently incapable of eliminating spatial and pictorial features from his work. Such was the inherent condition of sculpture. Bourgeois, who was also

present at the Artists Sessions, would experience the same type of spurning until the early 1980s, when MoMA assembled a retrospective exhibition of her sculpture, a project that contributed to its slow reappraisal and recognition. The obviously sexualised content of Bourgeois's work, with its lingering traces of Surrealism, had confused the issue for many of New York's critics. The painted white cluster of freestanding phallic wooden forms in *Quarantania* 1941

42
James Brooks
Untitled 1952

Tempera on gouache
and white oil paint on
paper
72.7 × 57.1
(28⅝ × 22½)
Cleveland Museum
of Art

(fig.44), for instance, was too literal and antagonistic to be folded into the rhetoric of purity.

While Bourgeois was a feminist from the outset of her career, she has ascribed the omission of her work from much of the writing on the New York School less to her gender than to what she viewed as the predatory

aspects of art criticism, stating in 1988 that: 'Many artists have been ignored. This is the problem. I don't think many are discriminated against, but many are certainly ignored. It is part of … the way man is a wolf to man.' With only a handful of artists privileged by the rubric of Abstract Expressionism, its exclusions were deemed by Bourgeois as a function less of one's sex than of the uncompromising and single-minded perspectives of its interpreters.

Other women artists of Bourgeois's generation, however, were not willing to relent on the issue of gender bias. Lee Krasner, for example, had emerged as a painter at the moment when Abstract Expressionism was in the midst of its gestation. In a small but prescient show organised in 1942 by the Russian-American artist John Graham for the McMillen Gallery in New York titled *French and American Painters*, Krasner was paired with de Kooning and Pollock and presented alongside Braque, Picasso and Rouault. The inclusion here would seem to have paved the way for her subsequent integration into the exhibition and discussion of New York School art. But Krasner became a marginalised figure until well into the late 1970s, long after the death of her husband,

43
Richard Lippold
Primordial Figure
1947–8
Brass and copper wire
243.8 × 61 × 45.7
(96 × 24 × 18)
Collection of Whitney
Museum of American
Art, New York.
Purchased with funds
from the Friends of the
Whitney Museum of
American Art and
Charles Simon

44
Louise Bourgeois
Quarantania 1941
Seven wooden pine
elements on a wooden
base
215.3 × 79.4 × 74.3
(84¾ × 31¼ × 29¼)
Gift of Anonymous
Donor. Collection of the
Whitney Museum of
American Art, New York

Jackson Pollock. In fact, up until that time, Krasner would be personified primarily either as a 'wife' or later as a 'widow', her professional identity as an artist overshadowed by her role as Pollock's partner. However, long before her marriage in 1945, she had worked (from 1934–43) in the mural division of the Works Project Administration (an agency established by the US government to help artists through the Depression), alongside figures such as de Kooning and Rosenberg (who was briefly de Kooning's assistant). It was there that she came into contact with many New York artists, forging significant friendships as well as a body of work that employed the languages of modernism.

Like Motherwell, Newman, Pollock, Still and many other Abstract Expressionist figures, it was Krasner's intent, as her painting evolved, to 'lose Cubism'. In works such as *Composition* 1949 (fig.45), with its grid of tiny squares and fanciful white writing, the picture plane has been completely annihilated, replaced by a flat surface. But when her work was juxtaposed with that of Pollock in a group show at the Sidney Janis Gallery in 1949 with the (now incendiary) title *Artists: Man and Wife*, which also featured works by Sonia Delauney and Sophie Taueber-Arp, it was passed off as derivative, too dependent upon Pollock's originality. In a review of the exhibition for *Art News* in October 1949, Gretchen T. Munson noted that it was:

a study in itself to observe how much or how little the wives have resisted the overpowering influence of their 'better halves' … There is a tendency among the wives to 'tidy up' their husband's styles. Lee Krasner (Mrs Jackson Pollock) takes her husband's paints and enamels and changes his unrestrained sweeping lines into prim little squares and triangles.

Krasner was perpetually put on the defensive by comments like these, repeatedly stating, 'I am not Pollock.' The singularity of her painting, its newness and invention and positioning of prototypical shapes and forms, would remain largely unnoticed until some thirty years later, when she finally became incorporated into the canon of Abstract Expressionism.

Krasner had once been friends with Rosenberg, but they had become estranged after the 'American Action Painters' – an article that ironically aimed to expand the domain of avant-garde art and to add to the score of its artists. In 'The Art Establishment', which appeared in *Esquire* of January 1965, Rosenberg's acerbic assessment of the art world and its infrastructure, he now made reference to the artist's widow as a new social type, depicted as a power broker. With Krasner presiding over the Jackson Pollock Estate, a highly lucrative body of material, her significance became (cynically) weighed by her control of the work of the leading Abstract Expressionist painter. Long after the essay was published she inveighed against the description, stating:

I was put together with the wives, and when Rosenberg wrote his article many years ago that the widow has become the most powerful influence … he never acknowledged me as a painter, but as a widow … And, in fact, whenever he mentioned me at all following Pollock's death, he would always say Lee Krasner, the widow of Jackson Pollock, as if I needed that handle.

45
Lee Krasner
Composition 1949
Oil on canvas
96.7 × 70.6
(38⅛ × 27⅞)
Philadelphia Museum of Art. Gift of the Aaron E. Norman Fund, Inc.

The second generation of female Abstract Expressionist artists hardly fared better. Frankenthaler was a notable exception, her work having benefited from Greenberg's critical support and his revised blueprint for the state of American art. Joan Mitchell, a friend and contemporary of Frankenthaler, like Krasner, received minimal recognition for her painting until relatively late in her career. The tight overlay of blue and yellow strokes of paint on a white ground in her *Hudson River Day Line* 1955 (fig.46), emerges as a latter-day refinement of the improvised character of gestural abstraction. However, unlike her forebears, Mitchell believed that art, or at least Abstract Expressionism, should not be measured exclusively by its degree of invention; that an ineffable moral code informed the decision to be an artist in mid-twentieth-century America. (And this stance, further, was one that she believed was unrelated to gender.) After years of reflection she declared in an interview of 1986 that 'Abstract is not a style. I simply want to make a surface work. This is just a use of space and form: it's an ambivalence of forms and space. When I was young, it never occurred to me to invent. All I wanted to do was paint.'

'Ambivalence' stands out as the operative word in Mitchell's statement, not only in relation to the compositional tension defined in her painting, but also in metaphoric terms, referring to a resistance to codifying the visual properties of art, to making them concrete and material. Yet the art world in New York in the early 1950s was not quite ready for a poetics of art. In 1950, Mitchell became a member of The Club, attending the always animated and sometimes contentious talks that pertained to the directions and themes in contemporary art. The term 'Abstract Expressionism', of course, would still continue to be a subject of dispute, engaging a number of panel discussions on its viability and meaning until well into 1962 when the operation folded. Within this unending polemic, Newman's earlier insistence that the 'image is concrete', typified the way in which art would continue to be described at many of these gatherings. Mitchell's notion of pictorial 'ambivalence', then, with its sense of equivocation, uncertainty and doubt, was one that was not ready to be absorbed by many members of The Club, running counter to the larger theoretical aims of the movement.

Richard Pousette-Dart, an artist who had surfaced at the onset of Abstract Expressionism, became over time an equally anomalous figure. While he was a widely exhibited painter, having participated in Putzel's *A Problem for Critics* show in 1945, as well as at venues such as Art of this Century and the Betty Parsons Gallery, he receded somewhat after 1950. In the wake of the Artists Sessions at Studio 35 and the 'Irascibles' photograph, and just as Abstract Expressionism had melded publicly as a movement, Pousette-Dart left New York for the country in order to raise his family. His ties to the New York School thereafter became increasingly distant and faded. But other factors also compounded his dwindling status as an artist. Throughout his career, he held on to the belief that the production of art was a deeply spiritual activity. Towards the end of his life he would continue to express (frequently in poem format), the sentiment that he had once outlined in an untitled poem: 'the spiritual in art is not figurative nor depictive of any special themes forms ideas

or so-called religious organisations or systems sects or beliefs; the spiritual in art is the inner substance & passion of wholeness & integration inclusion & dynamic balance of all opposites'.

Of course, the idea of the 'spiritual' was anathema to most of the formalist writers, as well as to Rosenberg's construct of 'action', no matter that Pousette-Dart advocated the abstract expression of his mystical interests. In paintings such as *Descending Bird Forms* 1950 (fig.47), with its loose underpinning of a grid and delicate dissection of a bird in flight enveloped by tiny constellations, the sense of a metaphysical state is all pervasive. The intangible,

46
Joan Mitchell

Hudson River Day Line
1955

Oil on canvas
200.7 × 210.8
(79 × 83)
McNay Art Museum.
Museum purchase with
funds from the Tobin
Foundation

spectral nature of these forms defies, moreover, Newman's specification that the 'image is concrete'. Pousette-Dart's ethereal worlds could never be subsumed into a formalist rhetoric of the flat picture plane that is absolute, the discourse that would continue to dominate critical writing on art until the late 1960s. His lot was also to become an outsider.

Norman Lewis, like Pousette-Dart, was also present at the Artists Sessions of Studio 35, participating in the debates on the denotations of the phrase Abstract Expressionism. While not a member of its subsequent incarnation,

The Club, he was highly active as a painter during this period, straddling the circles of the 306 group, a salon of artists, writers and musicians based in Harlem, as well as the New York School. Lewis, who had worked alongside Pollock, Reinhardt, Rothko and Smith on the Works Project Administration during the Depression, was a regular exhibitor at the Willard Gallery from 1946 through 1964. An important showcase for modernist art, the gallery also featured the painting of Tobey, Lippold and Smith. While Lewis's painting was written off by one of the few reviewers in 1949 as hackneyed and clichéd, 'too close for comfort to the style employed by Mark Tobey', this did not preclude his inclusion in some of the major exhibitions devoted to American modernism.

In 1951, for example, the curator Andrew Carnduff Ritchie drew on Lewis's work for *Abstract Painting and Sculpture in America*, a much-discussed exhibition organised for MoMA. One of the first of its type, the show constituted a

survey of American art from 1913 to the present. Within its broad parameters, the work of Lewis and the New York School was posited as an endpoint, one of the many signs that post-war American abstraction was now considered part of a distinct lineage and tradition. Like many of his contemporaries, Lewis had worked assiduously throughout the early and mid-1940s to rid his art of the figure. But as an African-American artist, the renewed aesthetic focus of his work, and its preoccupation with abstract features, took on a double meaning. The decision to forgo representation of black culture revealed a certain universal outlook that transcended issues of race. In 1949, he would write:

The content of truly creative work must be inherently aesthetic or the work becomes merely another form of illustration; therefore the goal of the artist must be aesthetic development and, in a universal sense, to make in his own way some contribution to

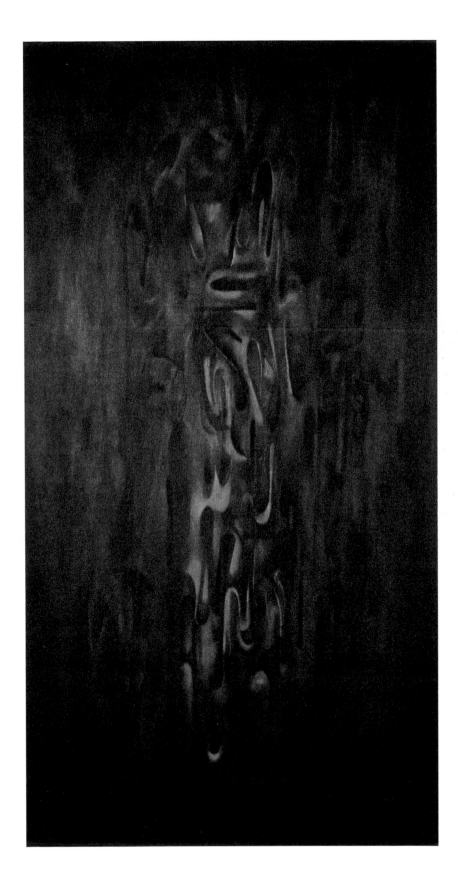

47
Richard Pousette-Dart

Descending Bird Forms
1950

Graphite and oil
on linen
121.9 × 243.8
(48 × 96)
Private Collection,
Starnberg, Germany

48
Norman Lewis

Mumbo Jumbo 1950

Oil on canvas
130.8 × 69.2
(51½ × 27¼)
Estate of the Artist

culture. Further, I realised that my own greatest effectiveness would not come by painting racial difficulties but by excelling as an artist first of all.

Mumbo Jumbo 1950 (fig.48), one of Lewis's prototypical paintings, with its undulating folds or ribbons of muted and dark paint, vaguely reminiscent of a totemic figure, is replete with mystery and symbolism. Metaphorically, the title alludes to an ancient African idol, now conjured by Lewis as a nebulous, undefinable object submerged in opaque washes of paint. But *Mumbo Jumbo* also operates as a personal conceit, a loosely veiled reference to Lewis's ethnicity and heritage. Critics such as Rosenberg had always pleaded for the private dimension of 'action' painting, that is, the withheld content and specificity of one's biography and interior life. In the distillation of these singular aspects and traits, Lewis's abstractions abided by the central concerns of abstract painting. But like the work of Pousette-Dart, as the decade of the 1960s unfolded, Lewis's painting would cease to be integrated into the reconceptualised programme of Abstract Expressionism, form now being the sole investigatory concentration of many artists and critics.

5

THE AFTERMATH OF ABSTRACT EXPRESSIONISM

There would be numerous permutations and off-shoots of Abstract Expressionism until well into the mid-to-late 1960s. Some of its second-generation practitioners such as Francis, Frankenthaler, Hartigan, Louis, Mitchell and Tworkov have already been mentioned. Within the poles of colour-field painting and gestural abstraction, further pictorial developments emerged that extended these twin styles of Abstract Expressionism, stretching its stylistic possibilities in unprecedented ways until the overarching theme of originality eventually became played out. Artists such as Norman Bluhm, Michael Goldberg and Alfred Leslie would continue to elaborate on the brushwork that had epitomised the work of de Kooning and Pollock, building on its improvisatory character and emotional surfeit.

Bluhm's *Hand* 1960 (fig.49), from a series of *22 Poem Paintings* that grew out of a collaboration with the New York poet Frank O'Hara, is emblematic of some of the latter-day aims of the movement. Its unrestrained drips and broad strokes of paint, rimmed by O'Hara's poem, have become an elegiac sign of the isolation of the artist and poet, and the near impossible task of marking the world with one's subjectivity and voice. Whatever attempt is made in *Hand* to fuse the work and identities of artist and poet, the unrelated, disparate text reinforces a sense of separateness. At the height of the Cold War, which constrained America's political relations with Russia and Eastern Europe, and along with a burgeoning material and conformist society, the plight of the artist had become endowed by Bluhm and others with a sense of tragic poetry.

The eminent art historian Meyer Schapiro would note in 1957 that the independence of the aesthetic stance taken by the Abstract Expressionists represented a 'liberating quality'. He would add, moreover, that 'No other art today exhibits to that degree in the final result the presence of the individual, his spontaneity and the concreteness of his procedure.' The splatter, skein and swathe of paint would continue to be seen by some interpreters such as Schapiro and Rosenberg as an existential act, the last surviving gasp of personal identity in American culture. In Bluhm's *Hand*, unpremeditated or extemporaneous compositional elements reign. A similar sense of tension and

disquietude can be found in the large-scale works of John Chamberlain, a second-generation Abstract Expressionist sculptor. In *Kora* 1963 (fig.50), an assemblage of discarded automobile parts is refashioned into an abstract mass of painted metal; the gesture (here of steel rather than of paint) becomes a sign, unconsciously or not, of the political unease of the late 1950s and early 1960s.

After Abstract Expressionism had become positioned as a direction in art, Motherwell acknowledged the complex task confronting a younger generation of art historians, curators and writers who attempted to make sense of the

movement. Commenting on a dissertation undertaken by William Seitz in 1955 on the New York School – the first on the subject – Motherwell later observed that the author 'does have difficulty in finding an essential Abstract Expressionist manifesto, but the very nature of a manifesto is to affirm forcefully and unambiguously, and not to express the existential doubt and the anxiety that we all felt'. The *leitmotif* of anxiety would always remain one of the governing themes of Abstract Expressionism. While the question of a community and common style was never reconciled, some conclusion as to its ethos was eventually made by the few original Abstract Expressionist artists who survived into the mid-to-late 1960s: the individual would always remain paramount.

While the second generation of gestural painters and sculptors such as

49
Norman Bluhm and Frank O'Hara

Hand (from *22 Poem Paintings*) 1960

Gouache on paper
35.6 × 48.9
(14 × 19¼)
Grey Art Gallery, New York University Art Collection. Gift of Norman Bluhm, 1966

50
John Chamberlain

Kora 1963

Painted steel
87 × 141 × 105.4
(34¼ × 55½ × 41½)
Tate

Bluhm, Chamberlain and Mitchell would expound on the improvised act in their work, an antipode existed in contemporary colour-field painting. Kenneth Noland, Jules Olitski and Larry Poons would, by contrast, drain their canvases of any vestige of emotion and angst, offsetting the theatricality of the heirs of de Kooning and Pollock. Taking their cues alternatively from Newman and Frankenthaler, their paintings became highly formal, analytic visual statements. The neat concentric circles of contrasting colour in Noland's *Drought* 1962 (fig.51), epitomise the sense of measure, balance and symmetry that came to order the paintings of this divergent branch of second-generation Abstract Expressionism. Devoid of the urgency of gestural abstraction, the brushwork in *Drought* is contained and controlled, not permitted to wander, drip and spill. The emphasis here is on pure visual

experience, on a retinal hit meant to be grasped in an instant. Where Newman's painting encouraged meditation, lulling the viewer to into an extramundane place, Noland's was devoid of any profound content.

The dispassionate tone of colour-field painting, especially as it evolved in the late 1950s and early 1960s, paralleled the reserved and emotionally withdrawn aspects of Pop art and Minimalism, artistic trends that surfaced contemporaneously. A more rational, detached approach to studio practice took over from the psyche as the subject of art. Colour-field painting became, in short, an endgame art, the ultimate fulfillment of Greenberg's formalist prophecy. While Greenberg knew art to be in a constant state of flux and re-

51
Kenneth Noland
Drought 1962
Acrylic on canvas
176.5 × 176.5
(69½ × 69½)
Tate

invention, he held out some hope that work aspiring to compositional purity, and which remained undefiled by either the figure or a sense of narrative, would have a better hope of lasting for posterity. Late in his life, he would write:

The conventions of art, of any art, are not immutable, of course. They get born and they die; they fade and then change out of all recognition; they get turned inside out. And there are the different historical and geographic traditions of convention. But wherever formalised art exists, conventions as such don't disappear, however much they get transformed or replaced.

Due to the zeitgeist of the 1960s, and its aversion to any overt display of the ego, the work of Noland, Poons and Olitski briefly overshadowed that of many of the gestural painters. However, neither strain of Abstract Expressionism survived beyond around 1968, no longer in sync with yet another new set of cultural priorities and concerns. Greenberg's critical authority, ironically, was rekindled during the 1960s, in large part by a younger generation of formalist acolytes (art historians and curators) who wrote about and exhibited the work of Noland and others with great conviction. The renewal of his ideas would prompt critics such as Rosenberg to rail against what they perceived as a new cultural conservatism. From the platform of the *New Yorker* magazine, for which Rosenberg became art critic in 1962 (a position he occupied until his death in 1978), he declaimed the growing spread and institutionalisation of formalist ideas both in the programming and collections of museums and in the teaching of art schools and academies. The purveyors of formalism, he argued, had become too powerful; its doctrine had seeped into too many areas of the art world, with the result that critical debate had become delimited and narrow.

Whatever the unique set of cultural circumstances in New York in the late 1940s that had given rise to Abstract Expressionism and its resounding originality and singularity, Rosenberg always maintained that no art was defined or demarcated by geography. The individuality of the artist, in his estimation, would always take precedence over consideration of the peculiarities of a country, city or state. Long after Abstract Expressionism had lost its aesthetic edge, and was superseded by new visual interests, Rosenberg would write:

With Gottlieb, Rothko [and] Newman ... as with post war French contemporaries like Soulages, Matthieu or Dubuffet, the sense of locality was entirely replaced by mythology, manner, metaphysics or formal concepts. For their art, the earlier requirements of actual or imaginative presence in a given environment had become meaningless. The declaration of independence from Paris resulted not in the establishment of an American art or New York 'school' but in the end of a need for one.

But Rosenberg's global or pan-cultural views were, for the most part, muted by the chorus of more nationalistic critics until the late 1960s, or perhaps even later. Other writers and historians such as Goldwater had early in the 1950s attempted to draw parallels between contemporary American and European visual expression, noting general stylistic correspondences and likenesses. In a review of an exhibition entitled *Younger European Painters*, organised by James Johnson Sweeney at the Solomon R. Guggenheim Museum in 1953, for example, which included abstract paintings by Georges Mathieu, Pierre Soulages and the French-Canadian artist Jean-Paul Riopelle, Goldwater observed that: 'comparisons with painting in the United States are, I suppose, inevitable. There are sufficient similarities between this painting and what is being done here to confirm the fact that the international background of the arts has broadened beyond continental boundaries.' The art of each continent would remain, however, separate and air-tight in the 1950s and later,

perennially scripted from the perspective of differing cultural histories, rather than from the consideration of some of its intersections.

Whatever occasional aesthetic overlap existed between European and American art in the late 1940s and through the 1950s, Abstract Expressionism would become the standard-bearer or new modernist criterion. The anti-nationalism of critics such as Goldwater and Rosenberg, as well as of numerous artists including Motherwell, never gained much of a footing, at least locally, and large-scale exhibitions of post-war art, when circulated both in the United States and internationally, would rarely if ever link the work of American and foreign artists. Abstract Expressionism, then, would be largely identified and construed as an American movement. Its dominance, naturally, would continue to incur the wrath of foreign critics. Patrick Heron, writing from London for *Studio International* in February 1968, long after the New York School had expired, argued that its advocates were engaging in a type of '"cultural imperialism" (as I'm afraid we must now label so much art criticism – or, rather art promotion – now emanating from the United States)'.

Abstract Expressionism, with all of its visual and thematic diversity, would certainly remain one of the most widely discussed of any artistic movement in the United States. Simultaneously heralded and disputed both nationally and abroad, its deep radicality and reinvention of modernist forms would indelibly mark the history of post-World War II art.

SELECT BIBLIOGRAPHY

Anfram, David, *Abstract Expressionism*, London, 1990

Barr, Alfred (ed.), *The New American Painting*, exh. cat., The Museum of Modern Art, New York, 1958

Belgrad, Daniel, *The Culture of Spontaneity: Improvisation and the Arts in Postwar America*, Chicago, 1998

Craven, David, *Abstract Expressionism as Cultural Critique: Dissent During the McCarthy Period*, New York, 1999

Franks, Pamela, *The Tiger's Eye: The Art of a Magazine*, Yale University Art Gallery, New Haven, 2002

Gibson, Ann, *Issues in Abstract Expressionism: The Artist-Run Periodicals*, Ann Arbor, Michigan, 1990

Gibson, Ann, *Abstract Expressionism: Other Politics*, New Haven, 1997

Greenberg, Clement, *The Collected Essays and Criticism*, John O'Brian (ed.), vols 1–4, Chicago, 1986–95

Greenberg, Clement, *Clement Greenberg, Late Writings*, Robert C. Morgan (ed.), Minneapolis, 2003

Jachec, Nancy, *The Philosophy and Politics of Abstract Expressionism*, Cambridge, 2000

Janis, Sidney, *Abstract and Surrealist Art in America*, New York, 1944

Kingsley, April, *The Turning Point: The Abstract Expressionists and the Transformation of American Art*, New York, 1992

Kootz, Samuel, *New Frontiers in American Painting*, New York, 1943

Leja, Michael, *Reframing Abstract Expressionism: Subjectivity and Painting in the 1940s*, New Haven and London, 1993

Motherwell, Robert, *The Collected Writings of Robert Motherwell*, Stephanie Terenzio (ed.), Berkeley, 1999

Motherwell, Robert and Ad Reinhardt (eds.), *Modern Artists in America*, New York, 1951

Newman, Barnett, *Barnett Newman: Selected Writings and Interviews*, John O'Neill (ed.), Berkeley, 1992

Ritchie, Andrew Carnduff (ed.), *Abstract Painting and Sculpture in America*, exh. cat., The Museum of Modern Art, New York, 1951

Rosenberg, Harold, *The Tradition of the New*, New York, 1994

Rosenberg, Harold, *The Anxious Object*, Chicago, 1982

Sandler, Irving, *A Sweeper-up after Artists: A Memoir*, New York, 2003

Shapiro, David and Cecile (eds), *Abstract Expressionism: A Critical Record*, New York, 1990

INDEX

PHOTOGRAPHIC CREDITS

Courtesy Albright-Knox Art Gallery 3, 33
Photograph: Dean Beasom 14
Photograph: Richard Carafelli 11
© 1987 The Art Institute of Chicago 19
Photograph: Geoffrey Clements, New York 21, 43
© The Cleveland Museum of Art 42
Courtesy of Dallas Museum of Fine Arts 4, 30
© Dedalus Foundation, Inc. 17
G.R. Farley Photography 32
Photograph: Brian Forrest 29
Courtesy of Grey Art Gallery 26, 49
Photo by Ecco Hart 1
Courtesy of Krannert Art Museum 10, 20
Photograph: Nina Leen 22
Courtesy of the McKee Gallery 31, 41
Courtesy of The Marion Koogler McNay Art Museum 46
Photograph © 1998 The Metropolitan Museum of Art 13, 15
© The Museum of Modern Art, New York 6, 25
© The Museum of Modern Art, New York/ SCALA, Florence 16, 27, 28
Photograph: Regina Monfort 12
Photograph: Lyle Peterzell 37
Courtesy of Philadelphia Museum of Art 45
Courtesy of The Estate of Richard Pousette-Dart 47
Photograph: Squidds & Nunns 35
Photograph: Lee Stalsworth 5, 7
Photograph: Frank Stewart, Courtesy of Landor Fine Arts, Newark, NJ 48
Tate Photography 2, 34, 36, 38, 40, 50, 51
Tate Photography/Marcus Leith cover

Photography by Jerry L. Thompson, New York 24, 44
Courtesy of Vassar College 8
Courtesy of the Walker Art Center 23
National Gallery of Art, Washington 39
© 1998: Whitney Museum of American Art, New York 9

COPYRIGHT CREDITS

The publishers have made every effort to trace all the relevant copyright holders. We apologise for any omissions that might have been made.

William Baziotes, Herbert Ferber, David Hare, Norman Lewis, Morris Louis, Joan Mitchell, Clyfford Still, Bradley Walker Tomlin, Jack Tworkov © Estate of the artist

Louise Bourgeois © Louise Bourgeois/VAGA, New York/ DACS, London 2005

James D. Brooks © DACS, London and VAGA, New York 2005

John Chamberlain, Hans Hofmann, Franz Kline, Lee Krasner, Barnett Newman, Jackson Pollock, Ad Reinhardt © ARS, New York and DACS, London 2005

Sam Francis © Estate of Sam Francis/ DACS, London 2005

Helen Frankenthaler © the artist

Arshile Gorky © ADAGP, Paris and DACS, London 2005

Adolph Gottlieb © Adolph and Esther Gottlieb Foundation/VAGA, New York/ DACS, London 2005

Philip Guston © The Estate of Philip Guston. Courtesy of McKee Gallery, New York

Willem de Kooning © Willem de Kooning Revocable Trust/ ARS, New York and DACS, London 2005

'Irascibles' photograph (fig.22) © Life Magazine

Richard Lippold © Richard Lippold Foundation

Robert Motherwell © Dedalus Foundation, Inc./ VAGA, New York/ DACS, London 2005

Kenneth Noland © Kenneth Noland/VAGA, New York/ DACS, London 2005

Richard Pousette-Dart © The Estate of Richard Pousette-Dart

Mark Rothko © 1998 Kate Rothko Prizel and Christopher Rothko/ DACS 2005

Aaron Siskind © Aaron Siskind Foundation. Courtesy Robert Mann Gallery

David Smith © Estate of David Smith/ VAGA, New York/ DACS, London 2005

Mark Tobey © Mark Tobey Estate